THE JOY
OF WEEDS

For Belle

First published in the United Kingdom in 2022 by
Portico
43 Great Ormond Street
London
WC1N 3HZ

An imprint of Pavilion Books Company

ISBN 978-1-91162-263-5

A CIP catalogue record for this book is available from the British Library.

10 9 8 7 6 5 4 3 2 1

Reproduction by Rival Colour Ltd, UK
Printed and bound by Toppan Leefung Ltd, China

www.pavilionbooks.com

The information in this book is not intended as a field guide. We
strongly recommend not picking or eating plants in the wild without
expert knowledge. Obtain the landowner's permission before
foraging. Herbal remedies should never be used as a substitute for
professional medical advice. This book is sold without warranties or
guarantees of any kind, and the publisher and the author disclaim any
liability for injuries, losses and damages caused in any way by the
content of this book.

THE JOY OF WEEDS

A CELEBRATION OF WILD PLANTS

PAUL FARRELL

PORTICO

CONTENTS

WHAT IS A WEED?

As an illustrator primarily and now an allotment holder, I have gradually become increasingly interested in the weeds that grow on and around my plot, rather than the conventional cultivated vegetables and plants. Their diversity, boldness, form and colour have given me the inspiration to study them in more detail and as a result I have created this companion book. Illustrating each weed was my main motivation for the book and writing about them has been an added, pleasant trip of discovery. I am not a fan of the word 'weed' and never have been. To call a plant a weed is doing it an injustice. For me, a weed is simply a wild plant. It is described as a plant that is not deliberately cultivated, growing where it is not wanted in human-controlled settings such as farmland, gardens, lawns and parks; the old English word for weed is *weod*, which means 'of unknown origin'. By definition, it is a plant that is not valued for use or beauty. Conversely, when a weed is classified as a herb, this means that parts of it can be used in medicine and cooking and it is appreciated for those benefits.

Admittedly there are certain weeds that I find less joy in and that do not appear here, such as bindweed, Japanese knotweed and the ever-present couch grass. These are truly invasive weeds or wild plants that need some degree of control if found on managed and cultivated land. Approximately 3 per cent – that's 8,000 out of 250,000 – of plant species found worldwide are classified as weeds.

Our unwillingness to embrace weeds is an indication of how we have abandoned nature and chosen to control our environment. With this book, I hope to show you the joy of weeds and to go some way to help rewild ourselves by understanding the benefits of weeds as medicines, food sources and importance for wildlife. One person's weed is another's treasured wild plant, first aid kit, fortified tea, salad garnish, ornamental cutting, power pollinator and all-round wild force.

We can all do our bit. Why not create your own wild garden? You can scatter a wildflower seed mix on a piece of bare soil or you can grow the seeds separately first and plant them out. In time some of your 'weeds' will be weeds no longer, and you will be richly rewarded by all the wildlife in your garden. So let your grass grow and your weeds live long.

WHY WE NEED WEEDS

Some of our most common weeds are actually wild herbs and their benefits have been recognized for centuries. Many have medicinal value, some are edible and nutritious, and they are all free. Plenty produce flowers that rival cultivated varieties as powerful pollinators, meaning that they are of enormous value to wildlife.

Weeds are much more important than we realize and play a key role in transforming degraded environments into valuable habitats. Weeds are good for the ecosystem, as they play a key role in transforming barren earth into rich, fertile soil. They are pioneers – the first plants to colonize bare ground and improve its soil. Their roots stabilize the earth and control erosion, while their stems trap organic matter. When they decompose, they increase the soil's moisture and nutrient levels.

The weed is an unsung hero and can tell you a lot about your garden and its soil, providing information about what is best to grow. They can indicate whether your soil is fertile, point to the soil type (acid or alkaline), signal various levels of nutrients within the soil and provide clues on density and levels of drainage.

An area full of weeds can be one large medicine cabinet. People have long turned to plants in the wild to relieve aches, pains and ailments, and as proven natural remedies they have been used in medicinal practices to treat patients for millennia.

Thanks to the physicians and herbalists who recorded their remedies in botanical encyclopedias, known as 'herbals', we know about weeds as wild plants and their ancient medicinal uses. For example, the roots of valerian,

a much-respected wild plant, has been a popular cure-all throughout history. This native European plant is now known to be effective as a sedative.

A large number of weeds are actually valuable food sources, loaded with antioxidants, vitamins and protein; there is evidence of many common weeds being grown for consumption throughout history. Weeds are hardy and can survive in conditions where more delicate plants would perish, and they have adapted to concentrate nutrients in their roots, stems, leaves, flowers and seeds.

For me, the most important benefit of weeds is that they provide shelter and food for all kinds of wildlife. Microbes, insects, birds and mammals all use and feed on weeds. There are many wildlife uses for these wild plants, including as a host to more insects than you could imagine. Most flowering weeds provide high-quality nectar for bees and butterflies, while some are the food plants for the caterpillars of particular butterflies and moths. Weeds also provide shelter, food and nesting material for the majority of birds. Take a look for yourself – get up close to a weed and see what you can spot.

I would encourage everyone to rethink, rewind and re-wild. Conservation groups are constantly encouraging and informing us about how we need to pay more attention to letting things grow in their natural state. For example, there are over 700 different species of wildflowers growing on road verges, accounting for 45 per cent of our native flora. Timely delays in mowing public green spaces and our own lawns can help germination – and beyond that, all will benefit from the new growth.

THE WEED TO HEAL

Herbalism is the study and use of wild herbs for their healing properties. The term 'herb' refers to every part of the plant – the roots, stem, leaves, flowers and seeds. Archaeological evidence indicates that humans were using medicinal plants during the Paleolithic period, around 60,000 years ago. If you have ever rubbed a dock leaf on a nettle sting, then you've practised herbal medicine.

In seventeenth-century England, physician Nicholas Culpeper used plants grown in the countryside to treat poor people in London for free. He wrote his *Complete Herbal* to share his knowledge of the medicinal properties of common plants, including weeds. Culpeper's magnum opus is the source of much of what we know about 'weeds' today.

How about making your own herbal medicine at home?

1. MAKE A HERBAL TEA
Making herbal tea is a common remedy for sore throats, coughs and colds. Dandelion and nettle are popular choices. Both fresh and dried parts of the plant can be used – simply rinse, add to the cup and pour over hot water. This infusion should be left for several hours to allow more vitamins and other nutrients to develop in your brew.

2. USE A HERBAL POULTICE
Common plantain is a healing weed that can be applied to small wounds and insect bites. Chew washed leaves until soft and then place the pulp on the affected area. Alternatively, you can finely chop the plant and place it in a cloth, or put it in a saucepan with water to soften.

3. TRY A HERBAL TINCTURE
A tincture is a solution of alcohol and water in which the plant is infused for a month and shaken twice a day. The daisy is a common weed on lawns and open areas of grassland. A daisy tincture relieves headaches, muscle pain and allergy symptoms. Try a 1ml drop as a dose, up to twice a day.

EAT YOUR WEEDS

Our gardens and open spaces, where weeds thrive, are living wild larders. Most wild plants are packed with nutrients from root to flower. Dandelions, for example, are a rich source of potassium and a good source of other minerals and vitamins. Here, I've hand-picked five other edible weeds regarded as superfoods, which pop up in the book.

1. CHICKWEED is a very nutritious weed with six times the amount of vitamin C, 12 times more calcium and 83 times more iron than spinach; it is even more nutritious than kale!

2. PURSLANE is eaten as a staple green in several cultures. Just one cup of raw purslane contains the following percentages of the daily recommended intake: 44 per cent of vitamin A, 35 per cent of vitamin C, 25 per cent of iron, 17 per cent of magnesium, 12.5 per cent of copper and almost 350mg of omega-3 fatty acids.

3. NETTLE is a foraging favourite, as it makes a nutritious early-season green. Tasty and versatile, it is a rich source of minerals including iron and calcium, along with vitamins including A, D and K.

4. BROADLEAF PLANTAIN is an entirely edible plant and is packed with nutrients, including vitamins A, C and K, as well as zinc, potassium and silica. Its seeds are rich in proteins, carbohydrates and omega-3 fatty acids.

5. WATERCRESS is a culinary delight, and its leaves, stems and fruit can all be eaten raw. It contains high quantities of vitamin A, vitamin C, riboflavin, vitamin B6 and calcium – and it is claimed that it contains more vitamin C than oranges!

Weeding your garden, allotment or containers could become the rewarding task of harvesting instead. The green leaves you collect could be destined for the pot rather than your compost bin. Flower beds and plots will be tidied and in return you will receive a free meal that introduces new flavours and methods of preparation, as well as many health benefits. However, do remember that not all weeds are edible. Please get yourself a good foraging book and be sure to identify things correctly.

WEEDS FOR WILDLIFE

Every growing season on my allotment, I place as much thought and importance on flowering wild plants as I do on the vegetable and fruit crops that I grow. My daughter asks me, 'Daddy, is there anything to eat here?' For me my plot is a place to stop and rest a while, not just to dig. At school my nickname was 'Nature Boy' and I wasn't happy unless I was out wildlife spotting each weekend.

If I can encourage and tolerate weeds and other flowering wild plants to grow, then all is well, as I know that our pollinators are in decline. Gardeners, local council and government, community open spaces and parks and beekeepers and farmers can all do their bit, too, and they are certainly doing so. Planting a wide variety of plants and allowing these green spaces to thrive and endure will in turn attract a wide variety of pollinating insects.

Weeds and wildlife go together like nettle and sting. Did you know that the common stinging nettle is a great wildlife weed? A single nettle patch can support over forty species of insects, and the plants provide food for caterpillars and so are particularly good for butterflies, especially small tortoiseshells and peacocks.

The Royal Horticultural Society (RHS) has created the designation 'Plants for Pollinators', which is used to highlight those plants that are particularly attractive to bees and other pollinators, such as wasps, moths, butterflies, flies and beetles. The list include the weeds below, which you'll find in this book.

- Bird's-foot trefoil
- Bluebell
- Creeping buttercup
- Daisy
- Dandelion
- Dog rose
- Foxglove
- Herb robert
- Poppy
- Red campion
- Red clover
- Rosebay willowherb
- Selfheal
- Spear thistle
- Teasel
- Wild carrot
- Yarrow

If you're struggling with the idea of introducing weeds into your garden or other green space, why not create a 'weedy corner', hidden from view by some sort of screen? That way you will allow weeds such as nettles, teasels and thistles to grow, and you will encourage wildlife without spoiling the look of your garden.

Giving over land to wildlife and allowing wild plants to grow is so rewarding and a good use of whatever space we have. It's also a wonderful gift for children and can help teach them to spot, identify and appreciate wildlife. Another top tip is to create a seed bank from the dried flowerheads of your plants at the end of each growing season. I have done this for many years and I'm able to reseed what I liked and what was successful – plus, because they are free and plentiful, I can donate leftover seeds to friends and family or simply sow them on any waste patch of land that I find.

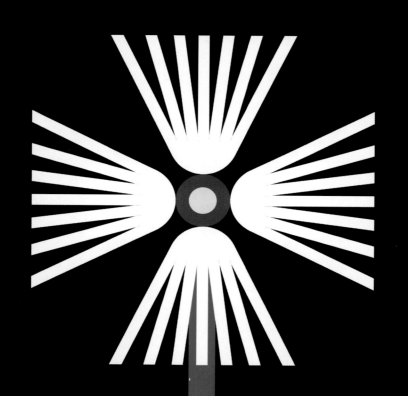

WEEDS
YOU NEED
TO KNOW

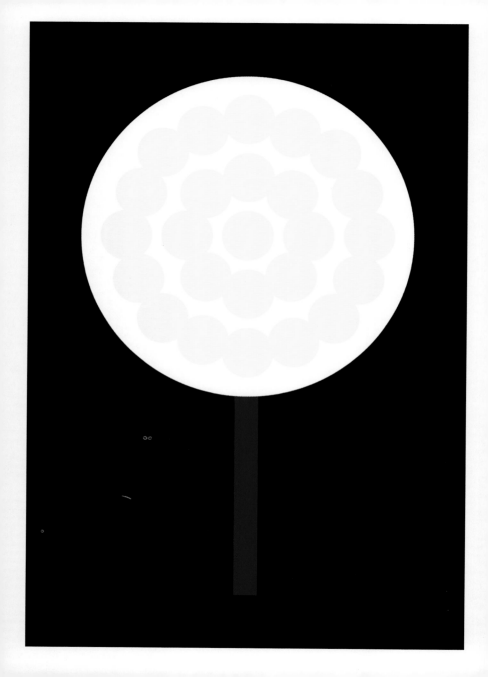

TAKE YARROW

- Common name: Yarrow
- Description: An upright herbaceous plant with small, daisy-like flowers.
 These are usually white but can be pink and are clustered together in
 groups that resemble flat umbrellas
- Flowering time: April–October (perennial/broadleaf)

Bouquets of yarrow brighten many grasslands, roadsides and waste ground.
The flowerheads are dense and fragrant and the feathery foliage superficially
resembles that of the wild carrot. Its soft, fern-like appearance is considered
an attractive addition to gardens.

Uses and benefits

Yarrow is a favourite among practitioners of plant medicine. Alongside
the dandelion, yarrow is another highly useful, globally available plants.
Traditionally yarrow has been used to stem bleeding and to treat fevers. The
leaves are edible with a sweet, medicinal, slightly bitter taste. The younger
leaves make a pleasant leaf vegetable in salads, can be cooked like
spinach, or included in soups or stews. Several cavity-nesting birds, including
starlings and blue tits, use yarrow to line their nests. It is also a source of food
for the larvae of over forty different species of moths and various beetles.

Weed the facts

- Yarrow was popular as a vegetable in the seventeenth century.
- The plant appears in many folklore traditions used to discover the identity of
 an unknown sweetheart – many involve placing yarrow leaves or flowers
 under a pillow so that the future lover would appear in a dream.
- The genus *Achillea* is named after the Greek hero Achilles. In the myth,
 his soldiers used yarrow to treat their battle wounds.
- Alternative common names include devil's nettle, lace plant and nose
 pepper. Others, such as nosebleed, carpenter's weed and soldier's
 woundwort, refer to the plant's ability to stem blood flow from injuries.

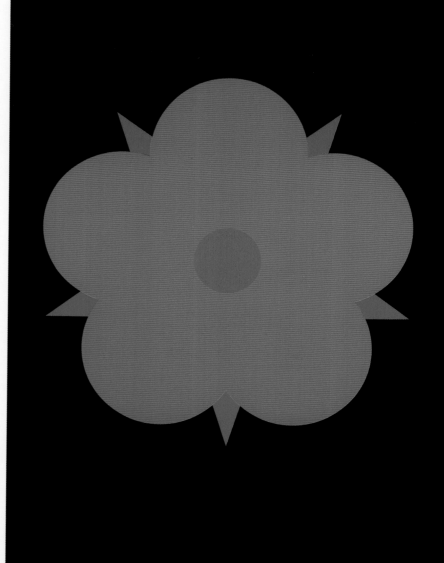

FIELD JEWEL SCARLET PIMPERNEL

- Common name: Scarlet pimpernel
- Description: A low-growing plant with oval-shaped leaves. The brightly coloured flowers can vary from orange through to salmon, and are borne singly on long, square stalks
- Flowering time: May–October (annual/broadleaf)

This wild flowering plant has, as its name suggests, bright, cheery small flowers that resemble a perfect miniature medieval Tudor rose. The long, slender flower stalks stand upright as the plant creeps among corners of open arable fields, waste ground and sand dunes.

Uses and benefits

Despite being toxic, scarlet pimpernel has been used in folk medicine, with the stems and leaves applied on the skin to heal ulcers and wounds. Some people also use the plant for depression, liver disorders, herpes, painful joints and to support the treatment of cancer. It contains chemicals that may be effective against some bacteria, fungi and viruses, but there is no good scientific evidence to verify this. Its bitter taste deters grazing livestock, which is fortunate as it has been known to poison cattle.

Weed the facts

- The flowers close in dull weather, hence the alternative common names shepherd's weatherglass and old man's weathervane.
- Scarlet pimpernel is a member of the primrose family, Primulaceae.
- It was used as an antidepressant in ancient Greece and in European folk medicine to treat psychological disorders.
- Scarlet pimpernel probably originated in the Mediterranean region but has now been introduced to most temperate parts of the world.
- *Anagallis* combines two Greek words meaning 'again' and 'to delight in', as the flowers open when the sun shines. *Arvensis* means 'of the fields'.

DISPLAY THE COW PARSLEY

- Common name: Cow parsley
- Description: A tall, fast-growing plant of shady roadside and woodland edges, with clusters of white flowers; its hollow stalks grow from a common centre
- Flowering time: April–June (perennial/broadleaf)

Like a sea of mini umbrellas, the white, delicate, lace-like sprays of cow parsley are a familiar and lovely sight. A hardy plant, loved by insects, it grows almost anywhere in shaded areas of woodland, grassland, towns and gardens.

Uses and benefits

In traditional medicine cow parsley was used to help treat various ailments, such as stomach and kidney issues, respiratory problems and colds. It can be used as a mosquito repellent, but there is the risk that it could be confused with giant hogweed (giant cow parsley), which can burn the skin. The young basal leaves taste, as you might expect, like a strong version of parsley, and can be used in similar ways, but forage with extreme care, as the leaves are very similar to poison hemlock or fool's parsley. Cow parsley is an important source of food and shelter for a variety of wildlife, from insects to mammals.

Weed the facts

- Another name for cow parsley is Queen Anne's lace, which comes from a folktale that the flowers resembled the delicate lace worn by Queen Anne (of Great Britain and Ireland, 1702–14) and her ladies-in-waiting.
- The young leaves of the plant are edible, but as cow parsley can be confused with a number of similar, poisonous species, it is best avoided!
- An alternative name for the plant, 'mother die' or 'mummy die', was used to frighten children into thinking that if they picked cow parsley, their mother would die – a way of deterring them from potentially picking deadly lookalikes.
- Cow parsley belongs to the Apiaceae family, also known as umbellifers. This large family includes over 3,000 species of celery, carrot and parsley.

BIG BOLD BURDOCK

- Common name: Burdock
- Description: A towering plant with a basal rosette of dull green leaves with waved edges and a heart-shaped base. The flowers, properly known as 'disk florets', are pink to purplish tufts
- Flowering time: June–October; roots harvested in autumn (biennial/broadleaf)

Many of us have encountered burdock while walking through fields or forest edges, but don't even realize it until we're pulling the Velcro-like, prickly seedheads or burrs from our clothing and footwear. It is the plant's globe-shaped, thistle-like flowers that become the burr-like seedheads.

Uses and benefits

Burdock is a traditional medicinal herb, used for many ailments but especially as a blood purifier and as a remedy for skin diseases and infections. Oil extracted from the root, also called bur oil, is used in Europe as a scalp treatment. As a food, the root is the best-known edible part of the plant. It is popular in eastern Asia. In Japan it is cultivated and sold under the name 'gobo' and in the UK dandelion and burdock is a drink that has been enjoyed since the Middle Ages. Originally a type of hedgerow mead, it is now available as a soft drink in supermarkets. Burdock flowers provide essential pollen and nectar for honeybees during high summer.

Weed the facts

- In Europe, burdock root was used in beer as a bittering agent before brewers began to use hops for this purpose.
- In the USA, burdock leaves simmered in milk have been used to neutralize the venom from rattlesnake bites.
- In ancient Greece, actors used the large heart-shaped leaves as masks.
- In 1948 George de Mestral, a Swiss inventor, developed Velcro after burrs from burdock stuck to his dog's fur after a walk.
- Some burdock leaves are large enough to provide shelter if you are caught in the rain when out for a walk.

DAISY DELIGHT

- Common name: Daisy
- Description: Each flower comprises a rosette of 15–30 small, thin white petals surrounding a bright yellow centre, supported by a single stem
- Flowering time: March–October (perennial/broadleaf)

Lawns studded with 'true' daisies announce the arrival of spring and the opportunity for making endless daisy chains. They are common in all types of turf – from carefully managed gardens to wild waste ground.

Uses and benefits

The daisy is as effective as arnica for treating bruises, hence its alternative name, 'bruisewort'. It has a particular association with childhood, and in homeopathy it is used to relieve bruising caused by childbirth, both for the mother and the child. The young leaves can be eaten raw in salads or cooked; the flower buds and petals can added to sandwiches, soups and salads. The plant is also used as a tea and contains high levels of vitamin C. Letting our lawns grow a little longer allows daises to flower more and provides a valuable food source for hoverflies, honeybees and bumblebees.

Weed the facts

- The name daisy comes from from 'day's eye' – referring to the flower's tendency to open when the sun rises and close when it sets.
- The flowers of the daisy follow the position of the sun in the sky, a phenomenon known as heliotropism.
- The genus name *Bellis* may come from *bellus*, Latin for 'pretty'; *perennis* is Latin for 'everlasting'.
- The English daisy is a symbol of innocence.
- Daisies belong to the Asteraceae plant family, which has around 24,000 species; it is so big that it is sub-divided into groups called tribes, including the aster tribe, the sunflower tribe and the thistle tribe. The daisy is sometimes known as the lawn or English daisy to distinguish it from others in the Asteraceae family.

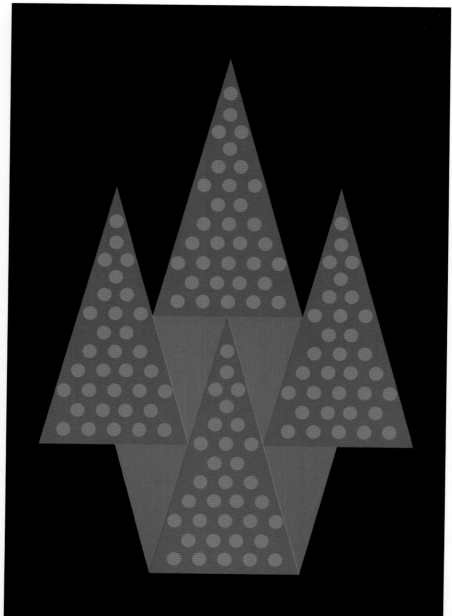

BUDDLEIA FOR BUTTERFLIES

- Common name: Buddleia
- Description: A large, vigorous shrub with honey-scented lilac to purple flowerheads carried in drooping pointed spikes or pinnacles
- Flowering time: July–October (annual/broadleaf)

If you like butterflies, then you will approve of the mighty buddleia, which is favoured by butterflies – hence its alternative name of 'butterfly bush'. One of Britain's most popular summer-flowering shrubs, it was introduced to the UK from China in the 1890s, and is now a common sight on waste ground, along railway cuttings and in urban areas.

Uses and benefits

As a cultivated variety, buddleia is widely used as an ornamental plant and is a popular flowering garden shrub. Buddleia is 'Mi Meng Hua' in Chinese and in China it is regarded as a traditional medicinal herb used to treat eye problems, headaches, muscle spasms, hepatitis, bladder problems, STDs and hernias. As well as butterflies, the flowers also attract a range of other insects as the flowers have a honey-like fragrance and are rich in nectar.

Weed the facts

- The genus was named *Buddleja* after Reverend Adam Buddle, an English cleric and botanist in the seventeenth century.
- The plant is also known as summer lilac and orange eye.
- In some parts of the USA certain cultivated species of buddleia, such as *Buddleja davidii*, are banned because the plants are able to self-sow and can be invasive.
- Buddleia symbolizes rebirth, resurrection and new beginning.
- The plant can attract astonishing numbers of butterflies. Author and naturalist, Richard Mabey, reported regularly seeing 'more than fifty individuals of up to ten species together on a single bush' in his own garden during August.
- Buddleias are colourful and fragrant as well as being an excellent way to attract wildlife to your garden.

WONDER WALL BELLFLOWER

- Common name: Wall bellflower
- Description: Violet-blue and bell-shaped flowers grow above a compact mat of small, bright green, rounded leaves. The plant will rapidly colonize cracks and gaps in walls and pavements
- Flowering time: July–August (perennial/broadleaf)

The hardy wall bellflower can be found cascading over walls and rockeries. When left alone in gardens, this wild plant provides a naturally beautiful display of trailing matted evergreen foliage and violet-blue flowers. From a distance it resembles a swarm of purple bees.

Uses and benefits

Wall bellflower does not appear to have any medicinal properties, but it is edible. The small leaves are produced all year round and can be eaten raw or cooked. They have a mild flavour and are a useful addition to mixed salads, especially in the winter, but be careful not to eat too many. The flowers are also edible; they have a pleasant flavour and look very attractive in salads. The nectar and pollen-rich flowers are known for attracting bees, insects and other pollinators.

Weed the facts

- Both the common and scientific names are derived from the bell-shaped flowers – campanula is Latin for 'little bell'.
- The plants can be pollinated by beetles, flies, bees and butterflies, but are also capable of self-pollinating.
- Ironically, planting wall bellflower is a good way to suppress other weeds and establish ground cover, while also creating a striking display in beds and rockeries.
- Bellflowers are a popular perennial in gardens; they are often grown in rock gardens, used as an edging, or in tubs and pots.

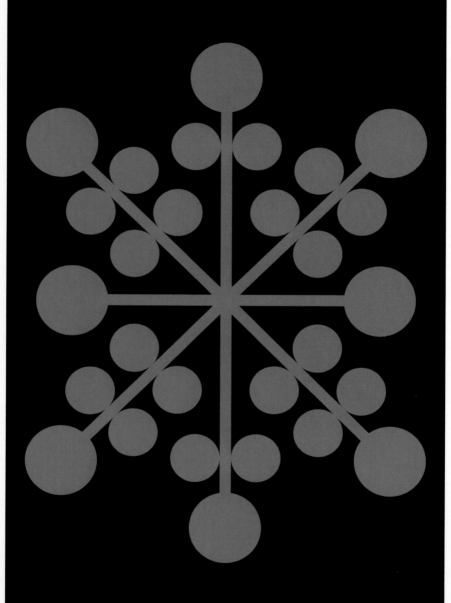

FLAVOURFUL
HAIRY BITTERCRESS

- Common name: Hairy bittercress
- Description: A compact edible herb, identified by a rosette of small,
 bright green leaves that radiate out from around the base
- Flowering time: March–August (annual and biennial/broadleaf)

This tiny, tender plant grows everywhere. Favoured by foragers as wild edible greens, it is sometimes called 'garden cress', 'pepper cress' or 'popweed'. You'll find it growing on bare earth, in grass and on walls and pavements.

Uses and benefits

Hairy bittercress is a member of the Brassicaceae family, together with mustards, cabbages and broccoli. Available all year and abundant throughout the UK, the soft, tender leaves have a sharp, peppery flavour not unlike watercress, which makes them an excellent addition to a salad. The flowers and seedpods are also edible. They can also be used as a garnish for sandwiches and soups. The roots can be blended with vinegar to make a sauce that is similar to horseradish.

Weed the facts

- The name hairy bittercress is not strictly accurate, as the plant only has a
 light covering of hair.
- Hairy bittercress contains high quantities of vitamin C as well as antioxidants,
 calcium, magnesium and other compounds that boost the immune system.
- The plant has a 12-week life cycle, which means that it can be harvested a
 number of times a year.
- Hairy bittercress flowers almost all year and self-pollinates; when the seeds
 are ripe, they explode from their pods and can be dispersed over 1m (3ft)
 away in all directions.

CENTAUREA NIGRA

FIRM FAVOURITE KNAPWEED

- Common name: Knapweed
- Description: Growing on straight stems with deeply divided, oblong leaves, knapweed has bright pink-purple, thistle-like composite flowerheads formed of many small florets
- Flowering time: June–September (perennial/broadleaf)

Knapweed is a tough wildflower meadow plant, and as a source of high-quality nectar it is a firm favourite among pollinating insects, especially butterflies. Like a cross between a cornflower and a thistle it stands out in any field, with its showy, ragged, pink-purple plumes.

Uses and benefits

Knapweed attracts all kinds of butterflies, including common blues, marbled whites and meadow browns, together with a host of bees and beetles. The seedheads provide food for many seed-eating birds such as goldfinches. Knapweed can be found in meadows, pastures, road verges, field borders, waste ground and woodland edges. The flowers are edible and can be added to salads, but the tough bracts are definitely not worth trying!

Weed the facts

- Knapweed is rated in the top five plants in Europe for nectar production.
- The plant is also known as black knapweed, and the thistle-like wildflowers are sometimes called 'hardheads', because the buds and flowerheads are firm and solid.
- In fourteenth-century Britain, knapweed was known as matfellon. Seasoned with pepper, it was eaten at the beginning of a meal to stimulate the appetite.
- In Wales during the twelfth century, a group of herbalists known as the Physicians of Myddfai included knapweed along with other herbs in a potion to treat adder bites.
- Knapweed was also used to soothe wounds, bruises, sores, scabs and a sore throat.

BORDER BEAUTY RED VALERIAN

- Common name: Red valerian
- Description: These tall stems, with their dense clusters of eye-catching, deep pink flowers, grow out of old stone walls, on roadside verges, in railway cuttings and on cliffs and rocks
- Flowering time: May–October (perennial/broadleaf)

We often see these tall, fleshy-stemmed plants at the entrance to our allotments and they appear to salute us each time we enter. The rich, almost fluorescent, raspberry-pink and crimson flowerheads create an ornamental, colourful display. The plants are very upright and their pale green leaves and stems contrast with the bright, fragrant flowers.

Uses and benefits

Although red valerian is reported by some sources to have medicinal properties, this is most likely due to confusion with common valerian (*Valeriana officinalis*), which is used to treat anxiety and insomnia. Both the leaves and roots of red valerian are edible; the leaves can be used either fresh in salads or lightly boiled, while the roots can be boiled in soups. Opinion differs as to whether either of these makes very good eating. Red valerian is a popular garden plant that is easy to grow and is cultivated for its cut flowers; the flowers are popular with many insects, including bees and butterflies.

Weed the facts

- Red valerian was introduced to the UK from Europe in the seventeenth century.
- It is an ideal garden plant; it flowers for a long period and attracts a variety of insects.
- Red valerian is also called devil's beard, fox's brush, kiss-me-quick and Jupiter's beard.
- The plant is native to the southern Mediterranean, North Africa and western Asia, and can grow in all types of soil, even the driest ones.
- The genus name *Centranthus* comes from the Greek words *kentron*, meaning 'spur', and *anthos*, meaning flower. The species name *ruber* is Latin for 'red' or 'ruddy'.

SPIRITED ROSEBAY WILLOWHERB

- Common name: Rosebay willowherb
- Description: Growing up to 1.5m (5ft) tall, the pretty pink flower spikes of rosebay willowherb are often seen on waste ground, woodland clearings and roadsides. Its lance-shaped leaves grow in a spiral up the stem
- Flowering time: June–September (perennial/broadleaf)

The striking, deep purple-pink flower spikes of this tall plant stand out like beacons above other plants and grasses. As a pioneer plant – a species that is among the first to colonize barren ground – rosebay willowherb thrives in waste places; you will often see it by the sides of roads and railway tracks.

Uses and benefits

Every herb garden should grow rosebay willowherb for its splash of colour and the buzz of bees. In cooking, the very young shoots can be treated like asparagus and served with butter and lemon or added to salads. Being caffeine free with a mild sedative effect, rosebay willowherb is often drunk as a tea close to bedtime. It is also known as an anti-inflammatory and an aid for digestion.

Weed the facts

- Following the Second World War, air attacks by enemy forces provided just the right conditions for this plant to thrive: in south-east London, one of its common names is bombweed and its colourful spikes became synonymous with the city's revival. In 2002 it was voted the County Flower of London.
- Fireweed, one of its other common names, refers to the fact that the plant will grow on burnt ground as the seeds can settle deep in the soil and remain viable for many years.
- For centuries in Russia, rosebay willowherb was used to make a traditional fermented tea known as Ivan Chai or fireweed tea.
- Rosebay willowherb contains ninety times more vitamin A and four times more vitamin C than oranges.

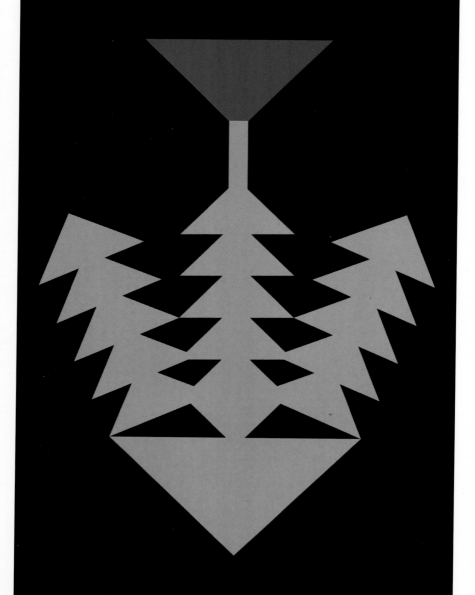

A FINE THING THIS THISTLE

- Common name: Spear thistle
- Description: A tall plant with flowerheads that comprise a cluster of pink florets above a ball of spiny bracts. The stems are winged and spiny and the upper surface of the grey-green leaves is bristly.
- Flowering time: July–October (biennial/broadleaf)

This striking plant is one of our most common thistles, found on disturbed ground such as roadside verges and field edges. As a biennial the purple, fluffy flowerheads appear every other year. There are around fourteen native species of thistle in the UK.

Uses and benefits

The spear or bull thistle is probably best known as a medicinal herb for its ability to treat swollen joints, while an infusion prepared with the leaves and roots is believed to heal a stiff neck and seizures. Although edible, it is not great to eat, but has been an excellent food for cattle and horses when the leaves are bruised or crushed in a mill to destroy the prickles. The seeds and pods of the spear thistle are attractive to birds such as goldfinches as a source of food and nesting material, and the flowers provide nectar for butterflies.

Weed the facts

- The spear thistle is in the top ten for nectar production in a survey of UK plants.
- Plants can grow up to 1m (3¼ft) in height.
- The thistle has been used as the national emblem of Scotland since the reign of Alexander III (1249–86).
- The ancient Order of the Thistle recognizes sixteen Knights and Ladies who have been significant in public life in Scotland.
- The dried florets steeped in water have been used in rural Italy for curdling goat's milk in preparation for making cheese.

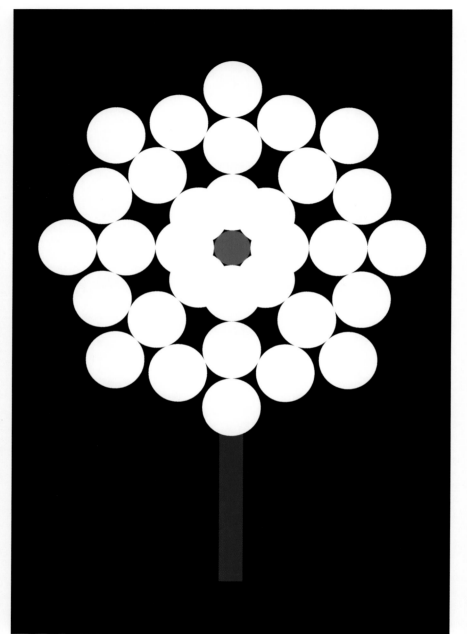

TIP TOP
WILD CARROT

- Common name: Wild carrot
- Description: This lace-like wildflower has a single red bloom at its centre. The flower clusters are long-stalked and shaped like an upturned umbrella
- Flowering time: June–August (biennial/broadleaf)

Wild carrot does, indeed, smell of carrots, but the roots are not like our cultivated orange favourite; instead, they are woody and off-white and can be forked or twisted. The small white-to-pink flowers are clustered in flat, dense umbels like cow parsley. When dry, the umbels detach from the plant and are carried on the wind like tumbleweed.

Uses and benefits

Oil from the seeds of wild carrot is said to provide relief for dysentery, indigestion and intestinal gas. Unlike cultivated carrots, wild carrot root is tough and stringy and not favoured by many. Its resemblance to poison hemlock (*Conium maculatum*) means you should be cautious about collecting it in the wild; no parts of the wild carrot should be consumed by pregnant or breastfeeding women. However, it is useful as a companion plant to other crops: it can aid pest control and assist with pollination by providing a habitat for beneficial insects and increasing crop productivity.

Weed the facts

- Wild carrot earns its name by its root's earthy similarity to the taste of our familiar orange vegetable.
- There are several stories about why wild carrot came to have the name Queen Anne's lace. One involves the consort of James I – Anne of Denmark – who is said to have pricked her finger and stained some lace with a drop of blood; with wild carrot's single red flower surrounded by lacy white blossom, you can see how this story might have arisen.
- Flowering between June and September and beloved by bees, wild carrot is a good plant to have in the garden, particularly around tomatoes.
- The seeds are very aromatic and can be dried and used as a spice.

FOXGLOVE LOVE

- Common name: Foxglove
- Description: A flowering stem or spike with small leaves and 20–80 nodding flowers
- Flowering time: June–September (biennial/broadleaf)

This biennial is a personal favourite of mine and is often grown as an ornamental plant due to its structural form and vivid flowers; it also thrives in open woodland and moorland. Like towering sentinels it hugs hedgerows, greeting walkers as they pass. *Digitalis* is a genus of about twenty species of herbaceous perennial plants, shrubs and biennials.

Uses and benefits

Despite being poisonous, the foxglove has been widely used as a medicine. The dried, powdered leaves are the source of the drug digitalis, which is used in the treatment of heart complaints. This powerful drug slows and strengthens the heart rate and stimulates the kidneys to remove excess fluid from the body. Foxgloves are also an important source of pollen for bees; the deep flowers are especially attractive to long-tongued bumblebees, such as the common carder bee.

Weed the facts

- The dark markings inside the flowers are called 'honey guides' or 'pollen guides'; these show up as ultraviolet light and are designed to attract bees.
- The word *digitalis* means 'finger' and describes the plant's long, thimble-like flowers.
- The species name, *purpurea*, refers to the pinkish purple colour of the flowers.
- Foxgloves are also known as witches' glove and dead man's bells, due to their toxic nature.
- Each flower last for about six days.
- A single plant may release 1–2 million seeds to ensure a population's continued survival.

THE MIGHTY TEASEL

- Common name: Teasel
- Description: This tall plant has spiny, egg-shaped, purple flowerheads that appear on long stems
- Flowering time: July–August (biennial/broadleaf)

The teasel has a dramatic, prickly silhouette. It is a plant best known for its brown stems and conical seedheads, which persist long after the plants themselves have died back for the winter. Teasels are popular in dried flower arrangements and at Christmas my mother sprays them gold and uses them for decoration.

Uses and benefits

Teasel plants contain a number of vitamins and minerals that are thought to help treat osteoporosis and rid the body of chronic Lyme disease. The root is considered to be an excellent diuretic. Goldfinches and other seed-eating birds like to feed on teasel seedheads, which is a very good reason to have them in your garden.

Weed the facts

- Water collected by the leaves of teasels was thought to remove freckles.
- Teasels are monocarpic – the flowers bloom for just one day and the plants die after flowering.
- A teasel plant may produce over 3,000 seeds.
- The name 'teasel' derives from the old practice of using the seedheads to 'tease' wool cloth to create a soft, furry surface, such as is found on the baize of card tables.
- Blue dye from the dried plant is a substitute for indigo.
- Teasels are sometimes grown as ornamental plants, and the dried heads are used in floristry.

SOLE SURVIVOR FIELD HORSETAIL

- Common name: Field horsetail
- Description: Horsetail is easily recognized by its upright, bright green, fir tree-like shoots that appear in summer. It grows from a tuber-bearing rhizome
- Flowering time: Fertile cones ripen March–May; sterile shoots May–October (perennial/broadleaf)

Field horsetail is a highly architectural member of the fern family with an almost prehistoric form. The sole survivor of a line of plants going back 300 million years, today it is widely distributed in the UK in meadows, gardens and on wasteland.

Uses and benefits

Horsetail has been used as a herbal remedy since Greek and Roman times, mainly to improve the health of skin, hair and bones. The 'doctrine of signatures' from the first century CE used a plant's appearance to deduce its medicinal application and the stems of horsetail bear a striking resemblance to human joints. It is now known that they are remarkably high in silica – a substance that preserves elasticity and connective tissue. Horsetail is mostly consumed as a tea, which is made by steeping the dried herb in hot water. Its diuretic properties can be helpful in combating bladder and kidney problems.

Weed the facts

- Horsetail has no leaves or flowers and grows in two stages. During the first stage a hollow fertile stem appears that is similar to asparagus; in the second stage, green barren fronds branch out from the plant. This is when the plant is gathered for medicinal use.
- Horsetail grew when the dinosaurs roamed the Earth. Fossil records show that in their heyday (around 350 million years ago), specimens reached 30m (100ft) or more; prehistoric equisetums created many of the world's coal deposits.
- Horses can die if they eat too many horsetails.
- Horsetails are native to every continent except Antarctica and Australasia.

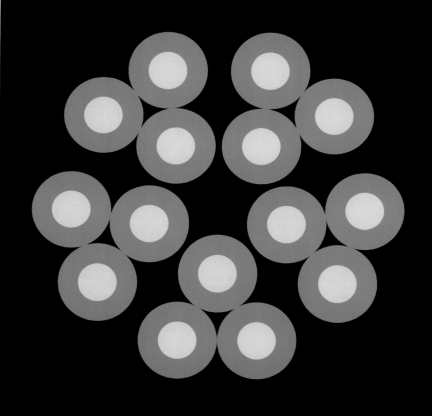

WORSHIP THE SUN SPURGE

- Common name: Sun spurge
- Description: Green-yellow flowers, borne on upright, solitary stems, are enclosed in a cup-shaped, leaflike structure. Each umbel has five bracts that are similar in shape to the leaves
- Flowering time: May–August (annual/broadleaf)

All in acid green, the single-stemmed complex 'flowers' remind me of little lettuces on stalks – or radar dishes. The species name *helioscopia* comes from the Greek for 'looking at the sun', as the flat flower canopies follow the light throughout the day.

Uses and benefits

The sun spurge is highly poisonous and not edible. It has been used in traditional Chinese medicine to treat various conditions, including swelling, coughs, malaria and dysentery. Its best-known use in Western folk medicine has been as a remedy for warts. Spurges from the deserts of Southern Africa and Madagascar are used as ornamentals in garden landscaping; they are popular not only because of their striking form, but also for their tolerance of heat and drought.

Weed the facts

- The genus *Euphorbia* is one of the largest genera of flowering plants, with over 2,400 species.
- Spurges have one female flower with a single female reproductive structure (the pistil) surrounded by a number of male flowers comprising one stamen each.
- Sun spurge is also known as mad-woman's milk, wart spurge and wartweed.
- The cut flower has a faint honey scent.
- The name 'spurge' comes from the Latin *expurgare* meaning 'to purge out' and refers to the purgative properties of these plants.

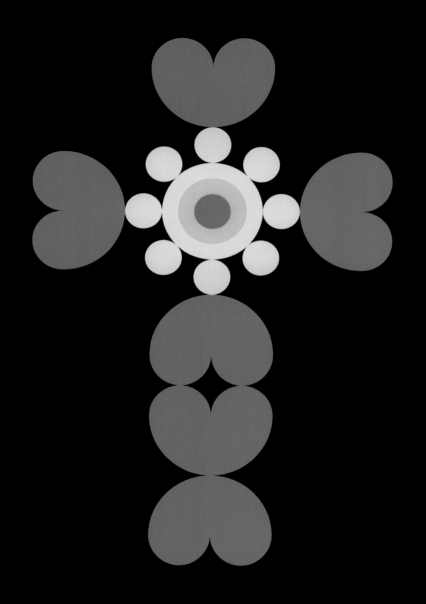

STAR BRIGHT LESSER CELANDINE

- Common name: Lesser celandine
- Description: A low-growing, hairless flowering plant in the buttercup family, with bright, glossy, star-like yellow flowers with 8–10 petals
- Flowering time: January–April (perennial/broadleaf)

Early spring is the time to look out for the cheerful yellow flowers of lesser celandine along path edges. These little yellow stars form carpets that brighten up woodland floors and grassy areas. Its leaves are glossy, dark green and heart-shaped with long stalks.

Uses and benefits

Lesser celandine was used as a traditional remedy for piles. The word 'fig' is an old name for the condition and one of the alternative names for the plant is figwort. An ointment made from the roots was also said to be a cure for corns. The leaves are high in vitamin C and have been used to prevent scurvy. As an early-flowering plant, it is an important nectar source for queen bumblebees and other insects coming out of hibernation. The plant has long been foraged as a wild edible, especially as its large fleshy roots and green shoots appear so early in the year.

Weed the facts

- Lesser celandine makes an appearance in *The Lion, the Witch and the Wardrobe* by C.S. Lewis. When Aslan returns and the woodland turns from winter to spring, 'Edmund saw the ground covered in all directions with little yellow flowers – celandines.'
- As the petals of lesser celandine close before it rains, it was once thought that you could use the plant to predict the weather.
- Wordsworth was not just a fan of the daffodil, he also wrote three poems about the lesser celandine: 'The Small Celandine', 'To the Same Flower' and 'To the Small Celandine'.
- A less common traditional use for the petals and leaves of lesser celandine, recorded in Cumbria, was for cleaning teeth.
- The appearance of the flowers is regarded by many as the start of spring.

GOOSEGRASS FOR A LAUGH

- Common name: Goosegrass
- Description: A creeping plant that grows along the ground; the stems and leaves are covered with tiny, hooked hairs that attach themselves to clothing and animal fur
- Flowering time: June–August (annual/grass)

You don't find goosegrass: it finds you. It is that long, hairy, sticky-stemmed plant, well known among children who throw it at each other as a game. It grows rapidly and can form dense patches, pulling down surrounding plants.

Uses and benefits

Goosegrass is generally very useful. It is diuretic and detoxifying – tea made from its fresh leaves can help tackle urinary problems and cystitis. The seeds can be roasted and it is claimed that they make an excellent coffee substitute; and the dried foliage was once used to stuff mattresses. In addition, the roots can produce a permanent red dye. Many insects feed on goosegrass, including aphids and spittlebugs. At the end of the growing cycle the flowers develop into globular fruits, or burrs. These are also covered with hooked hairs that attach themselves to people and animals, aiding seed dispersal.

Weed the facts

- Ancient Greek shepherds used the barbed stems, bunched and arranged in cross-hatched layers, to create a 'sieve' that could be used to strain milk.
- The Greeks called the plant *philanthropon*, meaning 'man-loving', due to its clinging nature.
- The name *Galium* is derived from the Greek *gala*, meaning milk; *aparine* comes from the Greek meaning 'clinging'.
- Geese particularly enjoy eating it, hence the common name goosegrass. Its other common names cleavers and sticky willy need no explanation!
- Goosegrass is native to parts of Europe, Africa and Asia, and probably to Scandinavia, Australia and New Zealand. It's not clear whether the plant has naturalized in the Americas or whether it is native, but it can now be found in the USA, Canada and Mexico, as well as Central and South America.

PRETTY IN PINK DOVE'S-FOOT CRANE'S-BILL

- Common name: Dove's-foot crane's-bill
- Description: A member of the geranium family, this low-growing plant has small, pink to purple flowers with deeply notched petals
- Flowering time: March– April (annual/broadleaf)

Dove's-foot crane's-bill is a spreading plant that forms clumps of stems with rounded, hairy leaves with distinct lobes. The small flowers, which vary from pink to purple, are dwarfed by the foliage, but make up for it with a pretty display. It grows in dry, grassy places such as meadows, pastures, verges and lawns, and can also be found on cultivated and waste ground.

Uses and benefits

Historically dove's-foot crane's-bill has many medicinal uses, including the treatment of gout, joint pain, muscle pain and colic, as well as bruises, cuts and open wounds. Although the leaves are not especially tasty, there are those who eat them or add them to smoothies. The most common herbal use is as a tea or extract.

Weed the facts

- A large plant can produce 1,500 seeds that are thrown a short distance from the plant by its explosive seedpods.
- It is also known as dove's-foot geranium.
- The name 'crane's-bill' is derived from the fact that when the flowers start to die back, the pistil or seed-bearing part of the flower and the calyx that surrounds the flower look like the heads of cranes, while the leaves are said to look like dove's feet.
- *Molle* means 'soft' and refers to the plant's soft, hairy nature.
- Writing in the seventeenth century, physician Nicholas Culpeper suggested a variety of uses for the plant, including the treatment of internal and external injuries; he noted that the bruised leaf helped external injuries to heal faster.

RED TURNER
HERB ROBERT

- Common name: Herb robert
- Description: A low-growing plant, with reddish stems and small, five-petalled, pretty, pink flowers
- Flowering time: May–September (annual or biennial/broadleaf)

Herb robert or bloodwort is a popular, colourful weed. Look for its bright pink flowers in shady spots in woods, grasslands and a variety of other habitats including hedgerows, rocky or exposed areas, stony slopes and on coasts. When it grows in open sites, the sunshine turns its stems a crimson red.

Uses and benefits

Traditionally herb robert has been used as an antiseptic, and to treat nosebleeds and stomach upsets. It was also use for ailments as varied as toothache, cancer, conjunctivitis, jaundice, gout and dysentery. It has been shown to reduce blood sugar levels and has been used as a treatment for diabetes. Its leaves are edible can be used as a tea; they can also be crushed and rubbed on the skin as an insect repellent. It provides a source of nectar for many insects, including bees and hoverflies, and is the food plant of the barred carpet moth.

Weed the facts

- The common name is thought to come from Robin Goodfellow, also known as Puck, a mischievous sprite from English folklore.
- Herb robert was used as a charm to bring good luck and for fertility.
- When crushed, the freshly picked leaves have a smell similar to burning rubber or diesel fuel.
- Some believe the plant can absorb radiation from the soil and break it down.
- Because the plant turns red, herb robert was thought to have the property of regenerating blood and was used to stop bleeding and to treat the kidneys – hence the alternative name, bloodwort.

A BLUEBELL SPECTACLE

- Common name: Bluebell
- Description: The bluebell is an unmistakable deep violet-blue, bell-shaped flowering perennial herb and wildflower
- Flowering time: April–May (perennial/broadleaf)

To enter a woodland that is carpeted in a vivid violet-blue sea of bluebells is an incredible spectacle and a magical experience. Their emergence is a sure sign that spring is in full swing. These sweet-smelling flowers nod to one side of the stem and have creamy white-coloured pollen inside. They occur in woodland, fields and along hedgerows.

Uses and benefits

Glycosides found in bluebells are poisonous to humans and animals, so there has been little use for the plant in modern medicine. However, their bulbs have been found to act as a diuretic and they can also help to stop bleeding. Bluebell woodlands are a haven for wildlife. The flowers appear earlier than many other plants, providing an important source of nectar for butterflies, bees and hoverflies.

Weed the facts

- Bluebells can reproduce by seed (sexually) or by growing new bulbs at the base of mature bulbs (asexually).
- The sticky sap from bluebells was once used for bookbinding and arrow-making. In Elizabethan times, starch for the ruffs of collars was made from the crushed bulbs.
- In folklore it was said that if you heard a bluebell ring, you would be visited by an evil faery and would die soon afterwards. Many believed that if you picked a bluebell you would be led astray by faeries and be lost forever.
- In the language of flowers, the bluebell symbolizes humility, constancy, gratitude and everlasting love.
- While the native bluebell is still common throughout Britain, it is threatened locally by habitat destruction, collection from the wild and hybridization with non-native bluebells.

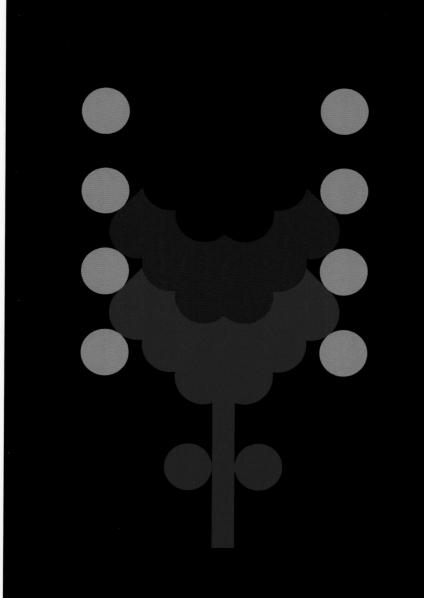

A RED DEAD-NETTLE DAY

- Common name: Red dead-nettle
- Description: This common plant has dense whorls of pale pink-purple
 flowers clustered towards the top of the plant. The leaves are hairy
 and heart-shaped, with toothed edges
- Flowering time: March–October (annual/broadleaf)

Wasteland seems to attract this easily overlooked wildflower, which is so
often buried beneath taller vegetation. It can also be found on disturbed
ground, such as roadside verges, and in gardens and hedgerows. Red
dead-nettle does not sting (hence the name 'dead').

Uses and benefits

The whole plant acts as an astringent, diuretic, purgative and styptic. In
traditional medicine the dried leaves have been used as a poultice to
staunch internal bleeding, while freshly bruised leaves have been applied to
external wounds. The leaves are also made into a tea and drunk to promote
perspiration and treat chills. When young the tops and leaves of the plant are
edible and can be used in salads or in stir-fries as a spring vegetable. Finely
chopped leaves can also be used in sauces. The pollen is red and can be
seen on the heads of bees that frequently visit its flowers.

Weed the facts

- Red dead-nettle is especially popular with bumblebees – hence one
 traditional name, bumblebee flower.
- It is a food plant for the caterpillars of the garden tiger, white ermine
 and angle shades moths.
- The flowers are hermaphrodites, with male and female reproductive parts.
- The genus name is derived from the Greek lamia, meaning 'devouring
 monster'; the shape of the flower resembles open jaws. Purpureum refers to
 the purple colour of the upper leaves.
- Another name, 'sweet archangel', may refer to the plant's lack of sting.
- Red dead-nettle was probably introduced to Britain with early agriculture
 and evidence to support this has been found at Bronze Age sites.

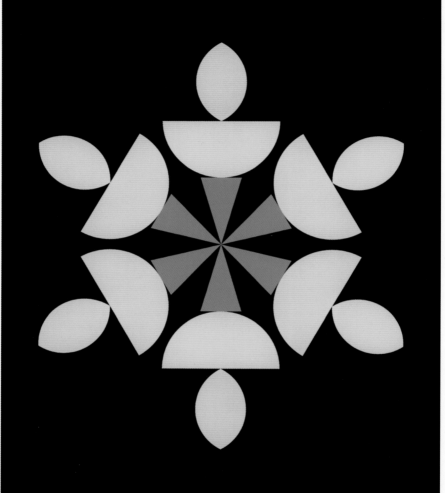

SUNNY BIRD'S-FOOT TREFOIL

- Common name: Bird's-foot trefoil
- Description: A member of the pea family, this plant has small clusters of deep yellow flowers with tinges of red, and delicate green foliage. It is found in all types of grassland
- Flowering time: May–September (perennial/broadleaf)

This is a very attractive common plant, with flowerheads that resemble puffed-up ball gowns. It is very familiar to walkers and motorists because so often it forms splashes of deep yellow that spill out from cracks between roadside paving stones and grass verges.

Uses and benefits

All parts of this plant are poisonous, but in the Sannio region of Italy to the north of Naples, the diluted infusions were traditionally used to calm anxiety and insomnia and treat exhaustion. Bird's-foot trefoil is an important food plant for the caterpillars of the common blue, silver-studded blue and wood white butterflies. The strong scent of the flowers attracts pollinating insects, including bees, as the blooms are an excellent source of nectar. In agriculture it is widely used as a forage plant grown as food for livestock due to its non-bloating properties, and it can also prevent soil erosion.

Weed the facts

- The seedpods resemble bird's feet or claws, hence the plant's common name.
- Other common names include granny's toenails, also derived from the shape of the seedpods; the names bacon and eggs and hen and chickens come from the red and yellow of the flowers.
- The genus name *Lotus* is distinct from the lotus flowers of Greek mythology and Egyptian art. The species name *corniculatus* means 'with small horns'.
- In the Victorian language of flowers, bird's-foot trefoil meant revenge.
- While the word 'trefoil' suggests that each of the leaves comprises three leaflets, there are actually five.

ONE STOP WATERCRESS

- Common name: Watercress
- Description: Watercress is a fast-growing, aquatic plant with small leaves, hollow stems and white and green flowers
- Flowering time: May–October; season March–November (perennial/broadleaf)

Watercress is one of the oldest known leafy vegetables eaten by humans and it is rich in vitamin C. Its hot, pepper-flavoured leaves are loved by many and used in a variety of ways. The hollow stems of watercress allow it to float in water as it thrives in cool flowing streams.

Uses and benefits

In cooking, watercress is widely used in green salads, soups and as a cooked vegetable. Watercress leaves, stems and fruit can be eaten raw and contain significant amounts of vitamin A, vitamin C, riboflavin, vitamin B6 and calcium. Cultivation of watercress is possible both on both a large and a small scale – it is definitely something to consider growing in your garden or on your windowsill. Like many plants in the cabbage family, the foliage of watercress becomes bitter when the plants begin producing flowers.

Weed the facts

- Watercress has been grown in the UK since the seventeenth century.
- In Victorian Britain, watercress was called 'the poor man's bread'; it provided ordinary people with a good portion of nutrition for the day in a sandwich and became one of the first foods that could be eaten 'on the go'.
- In the UK, watercress was first cultivated commercially in 1808 by the horticulturist William Bradbery, along the River Ebbsfleet in Kent.
- The town of Alresford, near Winchester in Hampshire, is considered to be the UK's watercress capital. It holds an annual Watercress Festival that attracts more than 15,000 visitors every year.
- Watercress is said to contain more vitamin C than oranges, more iron than spinach and more calcium than milk.

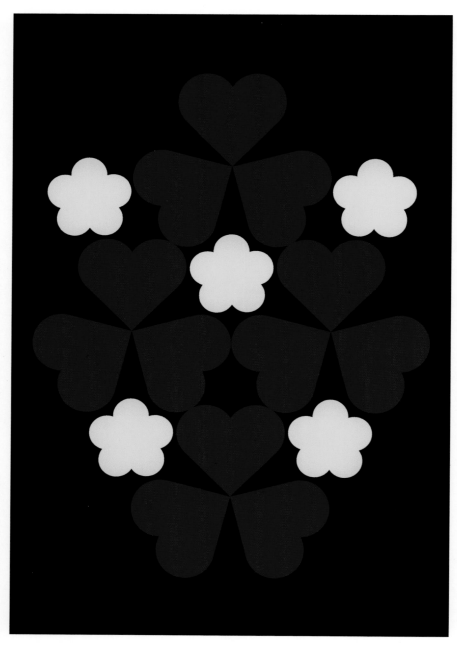

COLOURFUL CREEPING WOOD SORREL

- Common name: Creeping wood sorrel
- Description: A low-growing plant with eye-catching small yellow flowers and clover-shaped trifoliate leaves that range from light green to mauve
- Flowering time: April–June (perennial/broadleaf)

This small, delicate plant is beauty in miniature and the mauve-leaved variety is especially pretty – it is astonishing that the plant is classified as a weed! For me it is all about colour and form, and the contrast between the acid-yellow flowers and obcordate mauve leaflets is exquisite.

Uses and benefits

The entire plant is a good source of vitamin C and is used in the treatment of scurvy; juice from the leaves can be applied to insect bites, burns and spots. It is used extensively in traditional Chinese medicine. The leaves are edible and versatile, with a tangy flavour; a drink can be made by infusing the leaves in hot water for about ten minutes, sweetening and then chilling. The leaves can also be added to salads or used to give sourness to other foods. The flowers are also edible and can be used in salads.

Weed the facts

- Creeping wood sorrel folds its leaves up at night and opens them again in the morning. It also does this when under stress, such as when growing in direct sun.
- The plant is sometimes referred to as a false shamrock because of the shape of its leaves.
- It is also called yellow sorrel, pink sorrel, pink shamrock or sleeping beauty.
- When chewed, the leaves produce a slimy substance that has been used by magicians to protect their mouths when they eat glass.
- When the flowers are boiled, they produce yellow, orange and red-to-brown dyes.

UNFORGETTABLE POPPY

- Common name: Poppy
- Description: A tall, upright herbaceous plant with grey-green, lobed leaves. The colourful flowers have large, showy petals and dark centres
- Flowering time: June–September (herbaceous annual, biennial or short-lived perennial/broadleaf)

The poppy is the symbol of remembrance, and at the height of summer its striking flowers stand out from afar, painting fields with a vivid scarlet haze. It is found mainly on farmland, waste ground, field edges and roadsides.

Uses and benefits

The flowers of many poppy species are highly attractive and they are widely grown as ornamental plants, with a number of commercially important cultivars now available. A few species have other uses, principally as sources of drugs and food. The opium poppy (*P. somniferum*) is gown extensively for its dried sap, which can be used for pharmaceutical purposes; its production is monitored by international agencies. Poppy seeds are rich in oil, carbohydrates, calcium and protein. Poppy seeds contain small quantities of both morphine and codeine, which are pain-relieving drugs that are still used today. They can also be used in cooking, particularly in baking.

Weed the facts

- Poppy seeds only sprout when the earth around them is disturbed, which is why so many grew on the battlefields of the First World War.
- Since the First World War, poppies have become a symbol of remembrance of soldiers who have died during wartime.
- Some species of poppy are monocarpic, which means they die after flowering and setting seed.
- Poppies can be over 1m (3¼ft) tall with flowers up to 15cm (6in) across.
- Ancient Egyptian doctors used to administer to poppy seeds to relieve pain.
- For the ancient Greeks and Persians, the poppy was a symbol of love. It was also the sacred flower of Ceres, the Roman goddess of agriculture, and Demeter, the Greek goddess of the harvest.

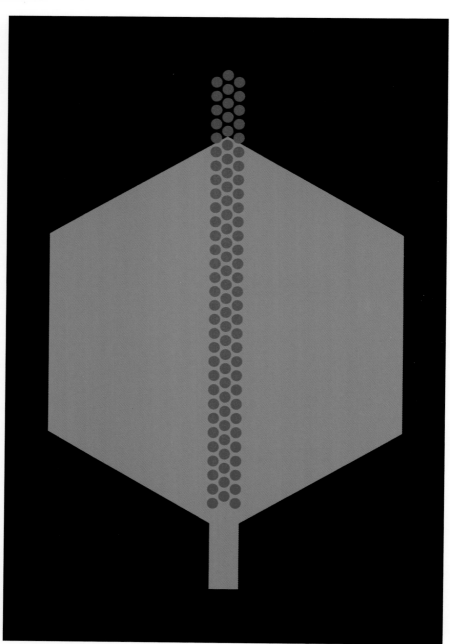

ESSENTIAL BROADLEAF PLANTAIN

- Common name: Broadleaf plantain
- Description: A herbaceous plant with a rosette of oval leaves with string-like veins that resemble those of celery. The flowers are small, borne on a dense, tall, thin spike, and change from green to brown as they mature
- Flowering time: June–September (perennial/broadleaf)

The broadleaf plantain has been described as 'the "weed" you won't want to be without'. The whole plant is edible, providing a wide range of nutrients, and it has a host of medicinal uses, from treating wounds to drawing out splinters.

Uses and benefits

Broadleaf plantain is highly effective in relieving insect bites, stings and other skin irritations – the fresh leaves can be chewed and then applied to the skin as a poultice. The root has been used to reduce fever and for respiratory infections. All parts of the plant are safe to eat – from root to seed – and it is packed with nutrients, including vitamins A, C and K, zinc, potassium and silica. The seeds are rich in proteins, carbohydrates and omega-3 fatty acids. The young, tender leaves can be eaten raw; older leaves can be boiled in stews.

Weed the facts

- Plantain can be found everywhere, from cracks in pavements to roadside verges and in meadows, gardens and parks.
- Apply fresh, ground plantain to the site of a splinter, cover with a bandage, and leave overnight. In the morning, the splinter should squeeze out easily.
- In one legend, Plantain was a young girl who longing for her lover's return. She waited so long that she transformed into this familiar roadside plant.
- In Native American folklore the plantain was given the name 'white man's foot', as the plant used to thrive everywhere the white settlers travelled.
- In Saxon times, plantain was regarded as one of the nine sacred herbs that protected against disease.

EAT YOUR PURSLANE

- Common name: Purslane
- Description: This succulent plant is regarded as an exotic weed and has small, green paddle-shaped leaves. Purslane flowers are yellow and star-shaped
- Flowering time: June–October (annual/broadleaf)

Purslane is a fleshy, leafy annual that grows throughout the world and is widely used. It's not picky about its habitat, and can be found growing in gravel, gardens, fields, bare ground and low-maintenance lawns, thriving best in warm and moist areas.

Uses and benefits

Purslane is used in traditional Indian medicine. The juice made from the whole plant is given to children against gastrointestinal worms (hookworms). Purslane is also said to be a natural remedy for insomnia. The plant may be eaten as a leafy vegetable, and the stems and flower buds are also edible, either raw or cooked. The plant has many of the same health benefits as other leafy greens but is much higher in omega-3 fatty acids and very high in vitamins A and C, as well as minerals including magnesium and potassium.

Weed the facts

- Introduced to North America from India and Persia, purslane is commonly called 'pigweed', 'little hogweed', 'fatweed' and 'pusley'.
- Purslane flowers open in the morning but will close at various times in the day, depending on the heat.
- Purslane seeds have been found at archaeological sites such as Iron Age Kastanas, near Thessaloniki in Greece.
- As well as having high levels of antioxidants, vitamins and minerals, purslane contains seven times more beta-carotene than carrots. It is one of the most nutrient-dense foods available.

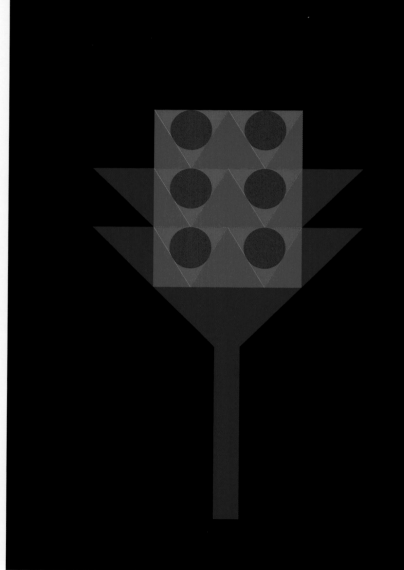

SELFHEAL FOR REAL

- Common name: Selfheal
- Description: Selfheal is a low-growing, creeping plant of grasslands, verges and lawns, with clusters of vibrant violet flowers
- Flowering time: May–August (perennial/broadleaf)

Selfheal pops up in late spring and favours short turf or woodland clearings. It is an unsual violet-blue wildflower with a dense, slightly oblong head held on a short erect stem. Its leaves are oval, hairy and often tinged with purple.

Uses and benefits

As its name suggests, selfheal was traditionally used in herbal remedies, particularly for sore throats, while its most common use is for the treatment of cold sores. The leaves and stems are said to have antibacterial, astringent and diuretic properties. The whole plant is edible, either raw or cooked, and is a powerful antioxidant. The leaves and young shoots can be eaten raw in salads, added to soups and stews, or used as a herb. Selfheal is included on the RHS Plants for Pollinators list and will certainly help attract bees to your garden.

Weed the facts

- The genus name *Prunella* is a misspelling of *Brunella*, a name for the genus that Linnaeus derived from *die Bräune*, the German name for quinsy (a type of throat inflammation). The name was then later misspelled as 'Prunella', but continued to be used in this form.
- The species name *vulgaris* means 'usual', 'common' or 'vulgar'.
- The striking flower spikes make attractive additions to floral arrangements, either fresh or dried.
- Selfheal first appears in Chinese medical records during the Han dynasty (206 BCE–CE 220) for ailments relating to the liver.
- A tea made from the root was used by Native American hunters to sharpen their powers of observation.

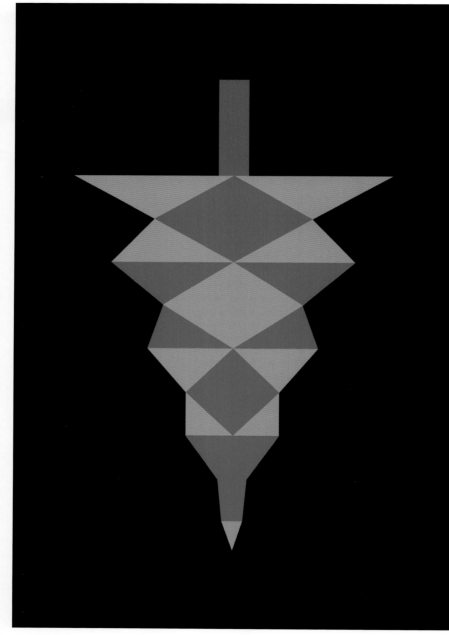

AWAKEN THE BRACKEN

- Common name: Bracken
- Description: Bracken is a large fern with green, triangular fronds. The fronds grow alternately along the stem and are divided into leaflets; these are sub-divided twice more, making them tripinnate
- In leaf: spring–autumn (perennial/broadleaf)

Wading chest high through a dense thicket of beautiful bracken, with its feathery touch and verdant smell, is a wild experience. Bracken is thought to be the most common plant in the world and is found on all continents except Antarctica. In the UK, it thrives in woodland and on moorland it is known as 'moorland scrub'.

Uses and benefits

Bracken has many varied uses. The young fronds, called fiddleheads, have been eaten by many cultures throughout history, either fresh, cooked or pickled. In the Mediterranean, the leaves are used to filter sheep's milk and for storing freshly made ricotta cheese. Another traditional use was as animal bedding, which could later be used as fertilizer. Bracken is an excellent habitat for nesting birds and provides cover for other wildlife. It is also the food plant of a number of caterpillar moths, such as the garden tiger and the brown silver-line.

Weed the facts

- The word bracken comes from Old Norse, related to the Swedish *bräken* and Danish *bregne*, both meaning 'fern'.
- It is one of the oldest ferns, with fossil records of over 55 million years.
- When damaged the young fronds produce hydrogen cyanide, which can poison animals that graze on it.
- It was said that witches would avoid bracken because, when cut, the stems showed the Greek letter 'X', a symbol of Christ.
- In Scottish folklore, the plant was thought to be an impression of the devil's foot.
- In parts of South America, bracken is used in rituals for cleansing the soul.
- The burned ash has many uses: for glass, soap, plant fertilizer and to control weeds.

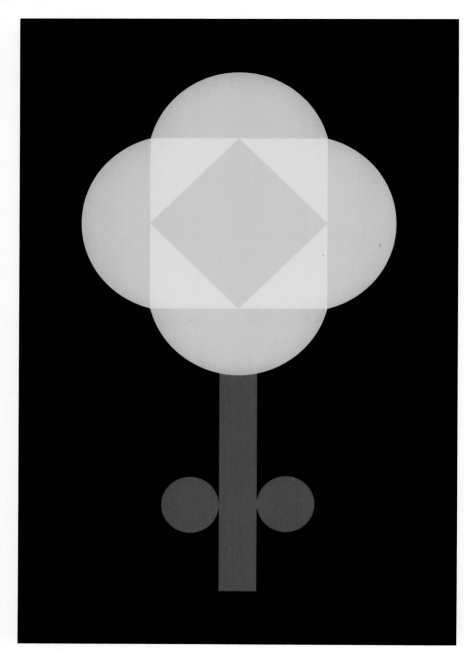

BEHOLD THE CREEPING BUTTERCUP

- Common name: Creeping buttercup
- Description: An attractive, low-growing wildflower with bright yellow, glossy, five-petalled flowers on tall stems
- Flowering time: May–August (perennial/broadleaf)

Who doesn't stop in their tracks at the sight of a meadow full of buttercups? These pretty, buttery-yellow flowers can be found peppering garden lawns, parks and fields. The creeping buttercup is our most familiar species and is an efficient colonist of disturbed ground, arable farmland and damp areas.

Uses and benefits

We all remember the childhood game of holding a buttercup under someone's chin to see if they liked butter – the answer would always be in the affirmative, as the yellow reflection was always present. Buttercups are poisonous (although they are harmless when dried) but despite these concerns, buttercups have been used in herbal treatments for arthritis, bronchitis and fever.

Weed the facts

- The gloss on a buttercup's petal is caused by layers of air under the surface that reflect the light, acting like a mirror. The gloss attracts pollinating insects as it reflects a significant amount of UV light that the pollinators can see.
- The genus name *Ranunculus* is derived from Latin and means 'little frog'. This may come from the fact that both frogs and buttercups are usually found near water.
- Creeping buttercup is pollinated by short-tongued bees because the flat, open flowers allow them to reach the nectar and pollen.
- Farmers used to think that if cows ate buttercups it would improve the colour of their butter; some would even rub the flowers on their cows' udders.

MEADOW MAKER YELLOW RATTLE

- Common name: Yellow rattle
- Description: An upright annual with dark-veined, toothed leaves and yellow, tube-like flowers that protrude from an enlarged green calyx
- Flowering time: May–August (annual/grass)

If you brush through a wildflower meadow at the height of summer, you may well hear the tiny seeds of yellow rattle rattling in their brown pods – hence the name. It outshines everything else, with its strong architectural form and golden-yellow flowers.

Uses and benefits

Known as the 'meadow maker', yellow rattle is the single most important plant involved in the creation of a wildflower meadow. Without it, vigorous grasses grow unchecked and smother other flowers. It is a hemi-parasitic plant that derives some of its nutrients from neighbouring plants. This weakens the tougher grasses, allowing more delicate wildflowers to thrive. There are no culinary uses for yellow rattle and little in the way of medicinal uses. The flowers are pollinated by large bees (especially bumblebees) and develop into large, inflated seedpods. When these ripen and dry, the seeds inside rattle around.

Weed the facts

- Yellow rattle is the food plant for the grass rivulet moth and is popular with butterflies such as the common blue, brimstone, orange tip and brown argus.
- It is included on the RHS Plants for Pollinators list and will encourage bees to your garden – the seed is widely available.
- Traditionally, the sound of the seeds rattling inside the seedpods was the cue for farmers to start cutting the hay.
- Yellow rattle has declined due to loss of hay meadows and agricultural intensification, ploughing and widespread use of herbicides.
- Cows are particularly keen on yellow rattle – it is the first thing they will eat when they enter a new field.
- The plant's leaves make a yellow dye.

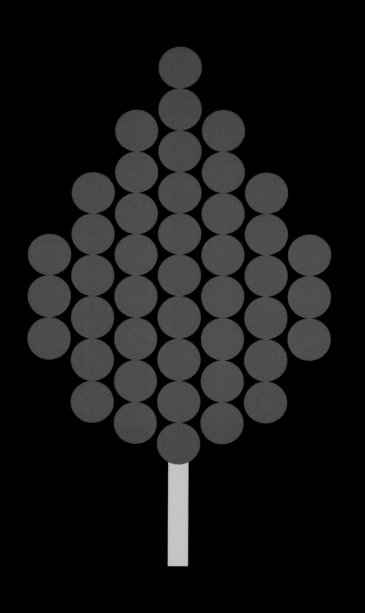

SPLENDID SUMAC

- Common name: Stag's horn sumac
- Description: This small deciduous tree or shrub bears spectacular fiery red clusters of berries and is extremely popular in the UK
- Flowering time: May–June; fruit ripens June–September (perennial/broadleaf)

Sumac is one of the best-known spices from the Middle East. As a plant it offers interest throughout the year: tall spikes of greenish yellow flowers appear in spring, followed by attractive, drooping foliage that becomes brilliantly coloured in autumn. Next, the fruits form clusters of red drupes called sumac bobs, which often last into winter.

Uses and benefits

In addition to its rich culinary history, the health benefits of this plant were first documented in ancient Greek medical texts, which recorded sumac's antiseptic qualities. The bark, roots and leaves were used as treatment for conditions as varied as diarrhoea, fever, piles, asthma, sore throats and boils. The dried fruits are ground to produce a tangy, crimson spice that is used worldwide to enhance and complement the flavours of food from grilled meats to desserts. The berries can also be used to make a nutritious pink 'lemonade' by steeping them in water and straining to remove the hairs.

Weed the facts

- The plant received the RHS Award of Garden Merit in 2002 to recognize its use as an effective landscaping shrub.
- Native to eastern and central North America, stag's horn sumac has been grown in British gardens for 350 years.
- Dried sumac bobs are used by some beekeepers as a source of fuel for their smokers.
- The pith inside sumac stems is easy to remove, which made the plant useful for traditional Native American pipe-making.
- Dried sumac wood fluoresces under long-wave ultraviolet radiation.

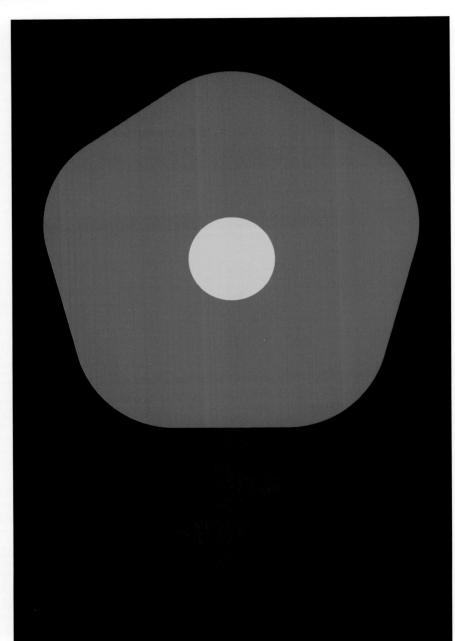

DOCTOR DOG ROSE

- Common name: Dog rose
- Description: With pinky-white flowers, this rambling shrub can be found in in hedgerows, woodlands and grasslands
- Flowering time: May– August (perennial/broadleaf)

This scrambling, thorny climber is a real beauty and the most abundant of Britain's native wild roses. Its sweet-scented flowers, which often grow in clusters of two or three, have a soft marshmallow colouring. In the autumn, the rose produces bright red hips that have endless uses and benefits.

Uses and benefits

It's the fruits of the dog rose – the hips – that are the stars of the show. They are a valuable source of vitamin C, and can be collected and used to make sweet rosehip syrups and jellies. This was especially important during the Second World War, when British commanders sent it to the front lines to boost the health of soldiers. The flowers can also be made into a syrup or added to salads and candied or preserved. The rosehips are a good food source for wildlife and are often eaten by birds and small mammals such as bank voles.

Weed the facts

- The root of a dog rose was thought to be able to cure the bite of a wild dog. In the fourth century BCE, Hippocrates used its roots to heal a wound caused by a dog's bite – hence the name *Rosa canina*.
- In the USA after the Second World War, the dog rose was planted in victory gardens; it can still be found on roadsides and in wet, sandy areas along the coasts.
- The dog rose grows widely in Bulgaria and the hips are used to make a sweet wine as well as tea.
- Other traditional names include dogberry and witches' briar.
- The strongly hooked, curved prickles help to support the dog rose as it weaves in between other plants and uses them to promote its growth; it can grow up to 3m (10ft) tall.

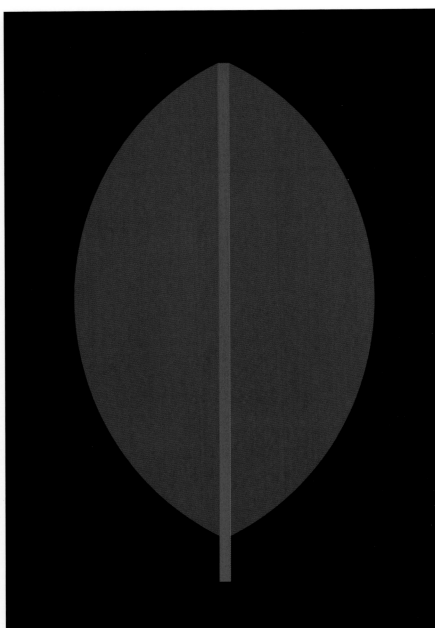

BROAD-LEAVED DOCK TO THE RESCUE

- Common name: Broad-leaved dock
- Description: A tall, erect plant up to 1m (3¼ft). The large leaves have wavy edges and red stems on their undersides. The flower spikes feature clusters of reddish-brown flowers
- Flowering time: June–October (perennial/broadleaf)

Dock leaves are present in almost every field, bit of waste ground, garden and lawn, and it is extremely likely that you have them growing or in a dormant state in your garden. The leaves are famously used to soothe nettle stings and often grow near the offending plant.

Uses and benefits

The cooling properties of dock can soothe insect bites and stings, and help to treat scalds, blisters and sprains. It's a first aid all-rounder: juice from the leaves can be applied as a compress to heal bruises; the seeds have been used to treat coughs, colds and bronchitis; and the roots to relieve jaundice, liver problems, skin ailments, boils, rheumatism, constipation and diarrhoea. In winter the seedheads provide a valuable source of food for wildlife, including birds, rodents and deer. It is an important host plant for many insects, including moths such as garden tiger, white ermine and blood-vein.

Weed the facts

- In the early nineteenth century, large dock leaves were used to wrap farmhouse butter.
- The milk of the dock leaf contains tannins and oxalic acid, which are regarded as an astringent and blood purifier.
- Dock seeds can survive in the soil for many decades.
- Used correctly, dock can act as a laxative by stimulating gut motion.
- The writings of Pliny the Elder describe how an infusion of dock leaves helped cure Julius Caesar's soldiers of scurvy.

RESPECT THE ELDER

- Common name: Elder
- Description: The elder is a fast-growing, adaptable small tree or large shrub that does well in most soil conditions
- Flowering time: May–August; the berries ripen between August and October (perennial/broadleaf)

Much favoured by foragers, elder is the very essence of summer with its shower of fragrant, creamy white flowers and clusters of dark fruits. It is abundant throughout the UK, in woodland and roadside hedgerows. Mature trees grow to a height of around 15m (50ft) and can live for 60 years.

Uses and benefits

The berries and flowers of elder are packed with antioxidants and vitamins that are thought to boost the immune system, ease inflammation, relieve stress and help protect the heart. Some believe elderberry can help prevent and ease cold and flu symptoms. In cooking the flowers are often used to make wine, cordial, tea and even champagne, or they can be fried in fritters. They are also important for wildlife: small mammals, such as dormice and bank voles, eat both the berries and the flowers; insects feed on the nectar, while elder is a food plant for many moth caterpillars, including those of the majestic swallowtail, buff ermine and dot moth.

Weed the facts

- Elderflowers contain both the male and female reproductive parts, which means that they can self-fertilize.
- Burning elder wood was thought to summon the devil; planting elder next to your house would keep the devil away.
- An alternative name is the 'Judas tree' as, according to early Christian tradition, Judas Iscariot is said to have hanged himself from an elder tree.
- The name elder is thought to come from the Anglo-Saxon *aeld*, meaning 'fire', because the hollow stems were used to revive a lacklustre fire like bellows.
- Elder is also used to make a variety of coloured dyes. The berries, bark and leaves were once used in the north of Scotland to make dyes for Harris tweed.

GOOD NEWS GROUNDSEL

- Common name: Groundsel
- Description: A common plant of rough and cultivated ground, its clusters of small, yellow flowers turn fluffy and white as the plant seeds
- Flowering time: All year (annual/broadleaf)

The leaves of groundsel are bright green, long, shiny and raggedly lobed. The flowerheads are borne in clusters at the ends of the stems and appear to emerge from little tubes.

Uses and benefits

Highly toxic to livestock, groundsel has a long history of use as a whole plant. It has been used as a poultice to draw pus from wounds and is said to be useful in treating stomach complaints such as colic, while a weak infusion makes a simple laxative. Groundsel is a good food source for caterpillars, its leaves and seeds are enjoyed by both birds and rabbits, and its fluffy seed crowns are widely used as food for caged birds.

Weed the facts

- The name groundsel comes from the Old English *grundeswilige*, meaning 'ground swallower', which accurately describes its invasive nature.
- Groundsel root was known as an old herbal cure for headaches.
- English apothecary and physician Nicholas Culpeper proclaimed the plant's many virtues: 'cooling in inflammations and is an easy emetic when made like tea. Taken in ale, it acts against the pains of the stomach ...'
- The Latin name *Senecio* comes from the seedheads and is derived from the word for 'old man' – if you pull the white, fluffy seeds off the flowerhead, they leave behind a bare, dotted 'scalp'.
- Groundsel (also known as ragwort) is a member of the daisy family, the Compositae, characterized by composite flowerheads, which are made up of lots of tiny flowers grouped together.

RED CAMPION CHAMPION OF THE WOOD

- Common name: Red campion
- Description: This pretty, vivid pink flower with tall, rich green stems is easy to spot in lightly shaded areas in woodland, fields and ditches
- Flowering time: May–September (perennial/biennial/broadleaf)

This bright dioecious woodland flower has five petals, like the blades of a fan, and is favoured by many insects. Its cheerful blooms appear soon after the bluebell has finished flowering.

Uses and benefits

Traditional medicine used red campion seeds to treat snake bites, while the roots contain saponin, a chemical compound that was long used as a laundry soap. Thanks to its lovely colour and relatively long-lasting flowers, red campion is popular with gardeners. The plant is also important for various pollinating insects, including bumblebees, butterflies and hoverflies.

Weed the facts

- This species is another important indicator species for ancient woodland.
- This striking flower has been mentioned in various poems and books, including Cicely Mary Barker's *Flower Fairies* series.
- Red campion's genus name, *Silene*, is from the Greek god of woodland, Silenus. His name comes from the Greek word *sialon*, which means saliva – the female plants secrete a sticky foam that helps attract pollen from insects.
- In folklore, red campion flowers used to guard bees' honey stores, as well as protecting fairies from being discovered.
- In the Anglican Church, red campion is associated with St James the Less, as the plant flowers around his feast day on 3 May.
- Red campion is also known as adder's flower, Robin Hood and cuckoo flower.
- It is a good source of food for hoverflies, bumblebees and butterflies, including brimstone, green-veined white and small white.

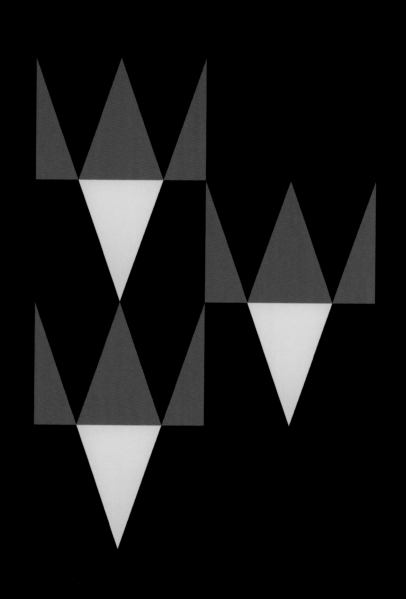

OH SO
BITTERSWEET

- Common name: Bittersweet
- Description: A woody, scrambling vine of dark, moist places, with
 star-shaped, purple pendulous flowers with protruding yellow stamens.
 It is a species of nightshade, with toxic fruit and foliage
- Flowering time: May–September (perennial/broadleaf)

This attractive, delicate plant pops out of the hedgerow with its striking purple
and yellow flowers. Its beauty disguises the fact that it is one of the most toxic
plants in its group; after flowering, its bright red berries hang in clusters.

Uses and benefits

Bittersweet has a long history in folk medicine, used externally in poultices
and salves to treat skin diseases, warts and tumours. In Germany the stems
are approved by the medical authorities for the treatment of chronic eczema.
Though toxic to people, bittersweet berries provide a source of food for some
birds, including blackbirds, song thrushes and robins. The flowers are also a
favourite of bees over its long flowering season.

Weed the facts

- Bittersweet is also known as woody nightshade and is related to
 tomatoes and potatoes.
- It has been valued by herbalists since ancient Greek times and in the
 Middle Ages was thought to be effective against witchcraft; it was
 sometimes hung around the necks of cattle to protect them from the evil eye.
- The species name *dulcamara* refers to the flavour of the berries which, if
 chewed, first taste bitter and then unpleasantly sweet.
- In one tradition, a sachet of the dried leaves and berries placed under
 the pillow at night was said to help heal a broken heart.
- The unripe berries and leaves of this wildflower contain the toxin solanine.
 They can be fatal when eaten in large quantities.

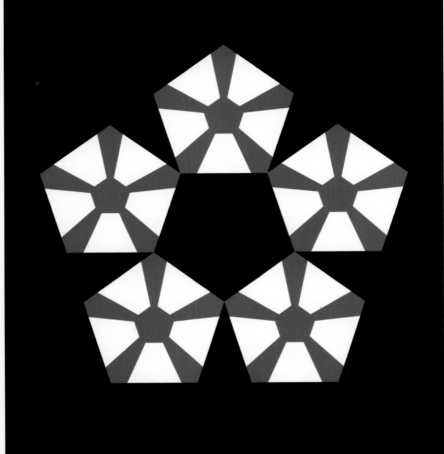

CHICKWEED INDEED

- Common name: Chickweed
- Description: Grows as lush, dense green mats with tiny, white, star-shaped flowers appearing in clusters at the tips of the stems
- Flowering time: All year round (annual/broadleaf)

Often found in gardens, the delicate white flowers of chickweed are a joy to behold. With large quantities of seed produced throughout the year, the plant is common in lawns, meadows, waste places and open areas.

Uses and benefits

Chickweed has been used to treat a variety of ailments and symptoms, including dermatitis, eczema, skin wounds and as a way to soothe rashes. The entire plant is edible and has been grown as a vegetable crop for humans and poultry. It is a juicy, succulent, delicate herb and can be eaten raw in sandwiches and makes a great base for salad. Chickweed is highly nutritious, with six times the amount of vitamin C, twelve times more calcium and eighty-three times more iron than spinach.

Weed the facts

- The common name chickweed comes from the fact that the plant is popular with birds and poultry, particularly young chickens. It is also known as starweed, satin flower or mouse-ear.
- Yet another name for chickweed is 'snow in the summer', because of its small, white star-shaped flowers. Although the plant can bloom at any time of year, the flowers are most noticeable between spring and autumn.
- The genus name *Stellaria* refers to chickweed's star-shaped flowers.
- Writing in the seventeenth century, English physician Nicholas Culpeper described chickweed as being beneficial for 'all pains in the body that arise of heat.'
- Chickweed is one of the ingredients in the dish of rice porridge with seven fresh herbs, eaten at the Japanese festival, *Nanakusa-no-sekku*, celebrated on 7 January. The fresh herbs symbolize health and energy.

COMFREY THE GREAT

- Common name: Comfrey
- Description: Large, broad, lance-shaped leaves borne on hairy stems, with clusters of bell-shaped flowers varying from white, through pale pink and mauve to dark purple
- Flowering time: May–July (perennial/broadleaf)

In groups, these mighty plants form a busy, buzzing plant citadel for bees. A common in sight in gardens, comfrey is a plant of damp ground and is also found beside rivers, in fens and ditches, beside roads and on waste ground.

Uses and benefits

Comfrey contains a substance called allantoin that helps to speed up the healing process. As a result, extracts from its leaves and roots are used to treat sprains, bruises and wounds, and to ease the pain of arthritis. Infusions of the plants were used in the treatment of gastric ulcers and other stomach complaints. Comfrey leaves can used in cooking, both raw and cooked, but there is some debate over whether this is safe or potentially harmful. The plant was first introduced to the UK as a fodder plant and is today used primarily as a type of organic green fertilizer.

Weed the facts

- Comfrey has been cultivated as a healing herb since about 400 BCE. The genus name *Symphytum* is derived from the Greek *symphyo*, meaning 'grow together'.
- The Greeks and Romans used comfrey to stop heavy bleeding, treat bronchial problems, and heal wounds and broken bones; poultices were made for external wounds and tea was consumed for internal ailments.
- To set broken bones, the roots of the plant were combined with other ingredients in the way that plaster of Paris is used today.
- The common name 'slippery root' comes from the large, black-skinned root, which is filled with slimy juice.
- Comfrey is a member of the borage family.

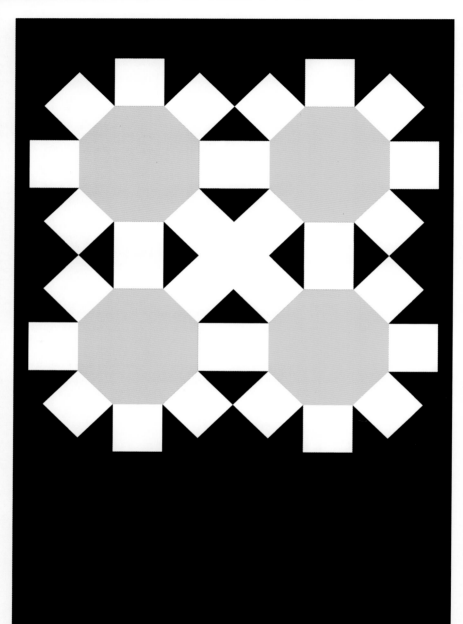

FEVERFEW FOREVER

- Common name: Feverfew
- Description: Feverfew is a flowering plant in the daisy family, commonly found in gardens and along roadsides
- Flowering time: June–October (perennial/broadleaf)

The name feverfew comes from the Latin *febrifugia*, meaning 'fever reducer', after one of its previous uses. Its conspicuous, cheery daisy-like flowers have white petals surrounding egg-yolk yellow inner discs. It is a herbaceous perennial that grows into a small bush, with pungently scented, light yellowish-green leaves.

Uses and benefits

For a small flower feverfew certainly packs a medicinal punch, and has traditionally been used for the treatment of fevers, arthritis, stomach pain, toothache, insect bites and infertility, as well as problems with menstruation and childbirth. Feverfew leaves are usually dried for medical use, and contain a number of different chemicals, including the anti-inflammatory parthenolide, which could help to prevent migraines. Its leaves are bitter and taste slightly of lemon but can add interest to salads; the dried leaves have been used as a flavouring for meat and beer.

Weed the facts

- Feverfew is native to eastern and south-eastern Europe, Turkey and the Caucasus, but can now be found around the world.
- Although its earliest medicinal use is unclear, feverfew was noted as an anti-inflammatory in the first century CE by the Greek herbalist physician, Dioscorides.
- Traditionally, feverfew was used to treat fevers; indeed, some people call it the 'medieval aspirin'.
- Do not plant feverfew near other plants that rely on bees for pollination, as they dislike the smell of feverfew and will stay away.

DEFENDING THE DANDELION

- Common name: Dandelion
- Description: A dandelion has large, round yellow flowers that mature into fluffy balls of white seeds known as 'clocks'
- Flowering time: May–October (perennial/broadleaf)

The dandelion is a British native perennial common to roadside verges. Its bright yellow flowerheads are like little bursts of sunshine above a rosette of jagged leaves. It is not just a source of frustration for gardeners, but is regarded by many as an important wildflower and coveted as a herb.

Uses and benefits

Dandelions have many uses in herbal medicine: the root has been used to treat stomach and liver complaints, as well as skin conditions such as acne and eczema. The plant contains beta-carotene, an antioxidant that helps protect human cells from damage and has bioactive compounds that may help lower a person's cholesterol. The entire plant, including the leaves, stems, flowers and roots, is edible and nutritious. It is a good early source of nectar and pollen for insects, so worth tolerating in the garden where possible. Dandelions are also good for your lawn as their roots spread widely, loosening hard-packed soil, aerating the earth and helping to reduce erosion.

Weed the facts

- The name dandelion comes from the French *dent de lion* – 'lion's tooth', which refers to the serrated leaves.
- The plant is thought to have evolved in Eurasia about 30 million years ago.
- In the language of flowers, the dandelion is a symbol of faithfulness and happiness.
- During the Second World War, when coffee was almost impossible to find, people made an alternative from the roasted and ground roots of dandelions.
- The dandelion flower opens in the morning and closes at night.
- Dandelions have one of the longest flowering seasons of any plant.
- The leaves of the dandelion have diuretic properties; the French word for dandelion is *pissenlit* (literally, 'piss in the bed').

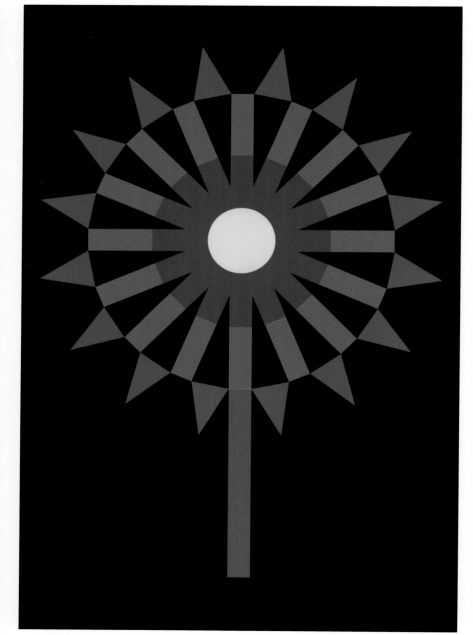

SO STATELY SALSIFY

- Common name: Salsify
- Description: This flowering plant and hardy vegetable has thin, grass-like leaves and knee-high stalks bearing composite flowers with purple rays surrounded by spiky green sepals
- Flowering time: May–September (biennial/broadleaf)

Salsify looks quite out of place in the wild, with its rather exotic, stately, purple-rayed blooms. It looks sharp, a plant with attitude, and is cultivated for its ornamental flower and edible root.

Uses and benefits

Salsify has been known since ancient times in Europe; it is both attractive and easy to grow. The cream or white vegetable root, which resembles a thin parsnip, is noted for its slightly sweet, oyster-like flavour. The young shoots and flowers are edible, too, and are often added to salads. Nowadays, salsify is increasingly finding its way into gourmet cuisine. The plant is grown in allotments, gardens and meadows to add a more ornamental look, and it also attracts useful pollinating insects, such as bees and butterflies.

Weed the facts

- The purple flowers start to appear after the plant has been growing for a few years.
- Cultivation in Europe began in the sixteenth century in France and Italy; it is now also grown in the USA and Asia.
- The flavour of the root, reminiscent of artichoke and oyster, has given rise to other common names such as oyster plant and vegetable oyster.
- The plant produces a seed clock similar to the dandelion clock, but it is more robust.
- The Latin name *Tragopogon* means 'old man's beard', which is probably derived from the seedheads.
- Salsify is a member of the sunflower tribe of the Asteraceae family.
- In warmer areas, such as California, the plant will flower as early as April.

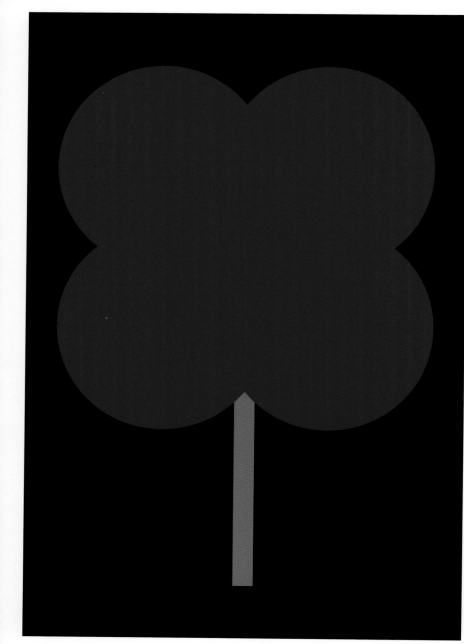

BE IN CLOVER

- Common name: Clover
- Description: Small, short-lived plants, clovers usually have three toothed leaflets (can be five or seven). Flowers are small and fragrant, packed into dense, almost round heads; they can be white, pink or red
- Flowering time: June–September (perennial/broadleaf)

A busy summer meadow buzzing with bees and other insects hovering above a carpet of clover is a wonderful sight. Clover is common in all types of grassy areas in the UK, from lawns to pastures, roadsides to meadows, and as both a wild and a sown flower.

Uses and benefits

Looking for a lucky four-leaf clover is a popular game among children and adults alike. Clover is a valuable addition to any garden lawn, as the flowers are highly attractive to bees – clover is an important nectar source for honey bees. Clover is a good fodder plant, as it is high in protein, phosphorus and calcium, thereby providing valuable nourishment for livestock. Clover honey is a common secondary product of the cultivation of clover. Clovers are most efficiently pollinated by bumblebees, which have declined as a result of agricultural intensification.

Weed the facts

- The shamrock, the traditional symbol of Ireland, is commonly associated with clover. According to legend, St Patrick used the leaf to explain the Holy Trinity.
- Clovers occasionally have four leaflets rather than three. Four-leafed clovers are considered lucky.
- Clover farms in the USA specialize in growing four-leafed clovers, which they sell as good-luck charms.
- In 2009, a farmer in Japan set the record for the most leaflets on a clover stem – fifty-six.
- As well as being valued as animal feed, clovers are important soil-improving and soil-conserving plants, because their root systems aerate the soil.

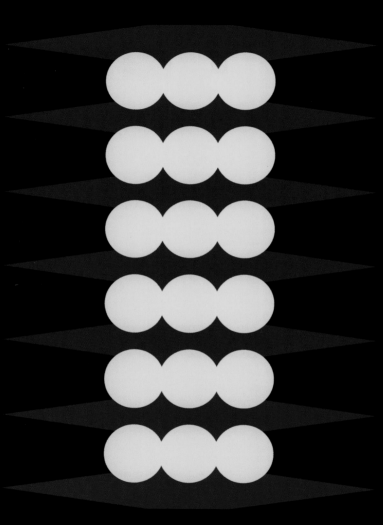

GORSE OF COURSE

- Common name: Gorse
- Description: Gorse is a large, evergreen shrub, covered in needle-like leaves and distinctive, coconut-perfumed, yellow flowers
- Flowering time: January–June (perennial/broadleaf)

In full bloom this regal evergreen shrub is a sight to behold, with its rich, egg-yolk yellow flowers and protective thorny foliage. Windy, open moorland is its typical habitat, but the plant can also be seen in towns, woodland, under-grazed grassland, heaths and coastal areas.

Uses and benefits

Gorse is valued for its ability to bring fertility and vitality to otherwise isolated and barren places and has been described as a remedy for hopelessness. As well as lifting the gloom of winter with its bright blooms, it also provides food and refuge for many insects and birds, such as Dartford warblers, stonechats and yellowhammers. It can also be used for hedging, boundary definition and groundcover in sunny, open locations. Gorse flowers are a good source of nectar for bees and butterflies, and the fragrant nature of gorse flowers means that they make a perfect addition to salads or steeped in water as a fruit tea.

Weed the facts

- Traditionally, gorse was collected by local people from common land and used in a variety of ways: as fuel for heating bread ovens; fodder for feeding livestock; as floor and chimney brushes; and as a dye.
- Gorse can be managed by controlled burning, as it regrows from the roots after a fire; the seeds are also adapted to germinate after heating.
- According to one saying, 'When kissing's out of fashion, gorse is out of bloom'. But, as the different species of gorse bloom at different times, flowers can usually be found year round!

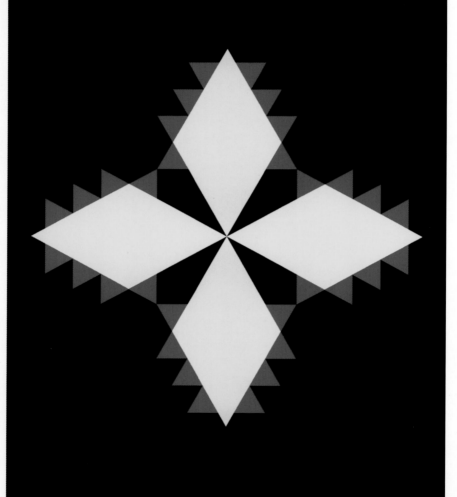

SETTLE FOR NETTLE

- Common name: Nettle
- Description: A herbaceous flowering plant of the nettle family, it has dropping, catkin-like flowers, a hairy stem and pointed, toothed leaves
- Flowering time: May–September (perennial/broadleaf)

The nettle has a well-known reputation for its uncomfortable, prickling sting caused by the hairs and bristles on the leaves and stems. However, this humble pant is incredibly useful, packed with nutrients and has long been a staple in herbal medicine. It is a leafy plant reaching 1.2m (4ft) tall, with pointed leaves and white to yellowish flowers, and is found in most temperate regions of the world.

Uses and benefits

The nettle is a highly nutritious plant with many applications in Western herbal medicine. It is thought to be helpful for urinary tract health, pain management for arthritis and reducing blood sugar levels, while compounds called polyphenols can help chronic conditions such as inflammation, obesity and heart disease. The plant has a wide variety of culinary uses: the dried leaves and flowers can be steeped to make a delicious herbal tea, while the leaves, stem and roots can be cooked and added to soups, stews, smoothies and even stir-fries. The plant is also very useful to wildlife: nettles are the food plant for many species of butterflies, such as the peacock, red admiral, comma and small tortoiseshell.

Weed the facts

- Nettles were used by ancient Egyptians to treat arthritis and lower back pain. While they were in Britain, Roman troops rubbed it on their arms and legs to help stay warm.
- The scientific name, Urtica dioica, comes from the Latin word uro, which means 'to burn'.
- Before the introduction of flax, nettle cloth was quite common in Scotland and was used at least until the eighteenth century for items such as sheets and tablecloths.
- Nettles are rich in iron and vitamins A and C.

CHARMING GERMANDER SPEEDWELL

- Common name: Germander (bird's-eye) speedwell
- Description: A low, creeping plant with upright spikes forming clumps of bright blue flowers with a white centre, hence the name 'bird's-eye'
- Flowering time: April–June (perennial/grass)

Germander speedwell is perhaps one of the UK's most charming, elegant and attractive wildflowers. It is found in grassland and woodland edges, creating dense patches of deep blue. The scarce red-girdled mining bee has a strong association with this flower, which is its primary source of pollen.

Uses and benefits

Germander speedwell has a number of medicinal uses, including as a diuretic and for the relief of chesty coughs. An infusion makes a relaxing tea, which can also be used as a tonic for cleansing the skin. As mentioned above, the plant is an excellent nectar source for solitary bees, and it is also one of the food plants for the caterpillars of the rare heath fritillary butterfly. Its blue flowers are extremely attractive and the plant can be grown in the garden; keeping the grass short in early spring can encourage growth.

Weed the facts

- In Ireland, germander speedwell was used as a charm to protect against accidents: the flowers were meant to 'speed' you on your way.
- *Veronica* is the largest genus in the plantain family, with about 500 species.
- The flowers wilt very quickly after picking, and in German the plant is called *männertreu*, which means 'men's faithfulness'.
- The species name *chamaedrys* in Latin means 'charisma' or 'gift'. The origin of the common name germander is sometimes ascribed to the corruption of *chamaedrys* – or of the Greek *chamai*, which means 'on the ground'.
- In eighteenth-century Britain, the plant was believed to be cure for gout and was so popular as a tea that it almost disappeared from London.

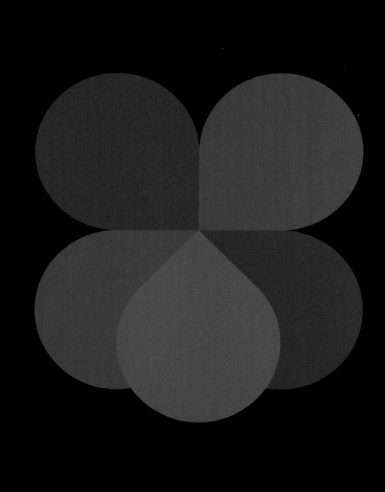

I HEART DOG-VIOLET

- Common name: Dog-violet
- Description: A low-growing plant with heart-shaped, deep green leaves that have a distinctive round-toothed or crenate edge. The purple-blue flowers have five overlapping petals that resemble a pansy; the centre of the flowers is paler
- Flowering time: May–June (perennial/broadleaf)

If you see a violet in the wild, it is most likely to be the dog-violet. This attractive wildflower favours shady spots in woods, heaths, hedgerows and grasslands. When it emerges it's a sure sign that the weather is becoming warmer and seeing its flush of purple on a woodland floor is a real treat.

Uses and benefits

It is possible to eat the young leaves and flower buds, either raw or cooked. Tea can be made from the leaves, which can also be used to thicken soup. You can also use the leaves in a wild salad; in spring the young leaves have a pleasant flavour with only a little bitterness. More importantly, dog-violet is the food plant for several rare fritillary butterflies, including the small pearl-bordered, the pearl-bordered and the silver-washed fritillaries; they also lay their eggs on the undersides of the leaves.

Weed the facts

- The ancient Greeks thought of violets as symbols of fertility and romance.
- In the language of flowers, if someone sent a purple violet it was a sign that their thoughts were 'occupied with love' for the recipient.
- 'Dog' refers to the plant's lack of fragrance, as opposed to the 'sweet' violet, which is scented.
- The dog-violet, also known as wood violet, is an important indicator species for ancient woodland.
- The plant can produce two types of flowers on the same plant: open flowers and cleistogamous flowers, which do not open but can self-fertilize.

WEED IDENTIFIER

BIRD'S-FOOT TREFOIL (*Lotus corniculatus*)

A member of the pea family, the yellow blooms of bird's-foot trefoil look like little gorse flowers and appear in small clusters. These are followed by seedpods that look distinctly like bird's feet or claws, hence the common name. A low-growing plant, its leaves are downy and have five leaflets.

BITTERSWEET (*Solanum dulcamara*)

This plant has yellow-green arrow-shaped leaves with pointed ends. The flowers are pendulous and purple, opening up like stars with a protruding yellow stamen. The fruits that follow are bright red, toxic berries.

BLUEBELL (*Hyacinthoides non-scripta*)

The bluebell has deep violet-blue bell-shaped flowers. Each sweet-scented bloom has six petals with upturned tips that droop to one side of the flowering stem. The bluebell has narrow leaves, 1–1.5cm (½in) wide.

BRACKEN (*Pteridium spp.*)

Bracken is a large, coarse fern and vascular plant with triangular fronds that divide into three. It can grow to a height of 1.5m (5ft) and in autumn the fronds turn reddish-brown. It grows in dense thickets that die back each year to make way for new growth.

BROAD-LEAVED DOCK (*Rumex obtusifolius*)

A tall, erect plant with large, wavy-edged leaves that have red stems on their undersides. The flower spikes have numerous sprays of small green and red flowers that are followed by similar coloured triangular fruits, which turn reddish-brown.

BROADLEAF PLANTAIN (*Plantago major*)

Oval- to egg-shaped leaves grow in a rosette on thick stems that meet at the base. Plantain flowers occur in compact spikes (about the size of a pencil) on leafless stalks from among the basal leaves. The spikes carry many tiny, stalkless, greenish flowers that give them a coarsely granular texture.

BUDDLEIA (*Buddleja davidii*)

A bush with drooping spikes of flowers at the end of the branches. The blooms can be white, yellow, pink, red or blue, but are typically purple; the flowers are nectar-rich with a honey-like fragrance. Buddleia has long, narrow leaves and can grow to 3m (10ft) in height and width.

BURDOCK (*Arctium* spp.)

A towering plant with a rosette of leaves with wavy edges and heart-shaped bases. The fleshy, round stems have many branches that bear very large leaves. Flowers are pink to purplish thistle-like disk florets. The prickly seedheads that develop after flowering are covered in hooked burrs.

CHICKWEED (*Stellaria media*)

Chickweed grows in lush, dense green mats that sprawl across the ground. Its tiny, white, star-shaped flowers appear in clusters at the tips of the stem. Bright green pointed, oval leaves occur in opposite pairs and the stems are green or burgundy, often with lines of white hairs.

CLOVER (*Trifolium* spp.)

A short-lived herb, usually with three petal-shaped leaflets. The tiny, fragrant flowers are crowded into dense, nearly spherical heads, and can be white, pink or red. The individual flowers are tubular in shape and have five narrow petals.

COMFREY (*Symphytum officinale*)

A bulky plant with large, hairy, broad leaves that feel rough to the touch. Flowers are small, drooping and bell-shaped in various colours from white through pale pink and mauve to dark purple. The roots are black and turnip-like. Comfrey grows in large colonies and tends to take over large areas.

COW PARSLEY (*Anthriscus sylvestris*)

A tall plant with sprays of small white flowers, and large, fern-like leaves. The flat, umbrella-like flowers, or umbels, are clusters that grow from a common centre on hollow stems. The plant spreads quickly and is a common sight in hedgerows.

CREEPING BUTTERCUP (*Ranunculus repens*)

A low-growing wildflower with bright yellow flowers on straight stems. The plant spreads by creating a dense network of shoots, runners and roots. The dark green, basal leaves are compound, borne on a long petiole and divided into three broad leaflets similar to those of flat-leaf parsley.

DANDELION (*Taraxacum* spp.)

Borne on a hollow stem, the yellow flowerheads of the dandelion are large and round, comprising many long petals. They develop into fluffy balls of white seeds called 'clocks'. The long green leaves have a heavily toothed edge and form a basal rosette.

CREEPING WOOD SORREL (*Oxalis corniculata*)

A low-growing plant with eye-catching small yellow flowers and clover-shaped trifoliate leaves that range from light green to mauve. On any ground the contrast of yellow blooms and mainly mauve leaflets makes the plant stand out. The stems are light green to reddish purple and hairy.

DOG ROSE (*Rosa canina*)

This wild, scrambling shrub has large pale pink and white flowers with five petals. Its stems are covered with small, strong, hooked thorns and its berry-like hips are bright orange-red. It ranges in height from 1–5m (3–16ft) and is seen in hedges and woods.

DAISY (*Bellis perennis*)

Each flower has a rosette of 15–30 small, thin, white petals or rays surrounding a bright yellow centre. The flowers are supported by single, smooth stems with no leaves, rising from a main plant with spoon-shaped leaves that form a rosette at its base.

DOG-VIOLET (*Viola riviniana*)

This beautiful wildflower has heart-shaped, deep green leaves and striking purple-blue flowers, with five overlapping petals resembling a pansy; the centre of the flower is paler and it has no scent.

DOVE'S-FOOT CRANE'S-BILL (*Geranium molle*)

Multiple stems rise from a single root base and the leaves form a basal rosette. Stems and leaves are downy. Small flowers, from pink to purple, sometimes with a white centre, are dwarfed by the leaves. The flowers appear to have ten petals, but if you look closely, you'll see just five.

ELDER (*Sambucus nigra*)

A single plant comprises many woody, short trunks producing few branches that carry scented flat umbels of creamy flowers; these are followed by small, round clusters of black berries. The leaves are broad and feather-like, consisting of 5–7 oval, toothed leaflets that smell unpleasant when bruised.

FEVERFEW (*Tanacetum parthenium*)

An attractive flowering plant with many small, daisy-like flowers that have white petals and yellow centres. Feverfew grows rapidly in a small, bush-like form with light yellow-green, aromatic pinnate leaves.

FIELD HORSETAIL (*Equisetum arvense*)

Easily recognized by its upright, bright green fir tree-like shoots that appear in summer, field horsetail has conspicuous joints along its fluted, ridged stems that grow from a tuber-bearing rhizome. Its spiralling, regular and ascending groups of branches give it the appearance of a Christmas tree.

FOXGLOVE (*Digitalis purpurea*)

A flowering stem or spike with small, oblong leaves and a cluster of pendulous, bell-shaped flowers hanging to one side that are typically purple. The inside of each bloom is spotted with a darker colour surrounded by white. The foxglove can grow to up to 1.5m (5ft).

GERMANDER SPEEDWELL (*Veronica chamaedrys*)

A low, creeping plant, germander speedwell has upright spikes forming clumps of small, bright-blue flowers with a white middle. Scalloped-edged leaves grow in pairs, and heart-shaped seedpods grow on the stem below the flowers. It forms patches among grass or hedgerows.

GOOSEGRASS (*Galium aparine*)

A characteristic feature of goosegrass is its very flat stems. It is a creeping plant that grows along the ground and supports itself with small, hooked hairs that grow out of the sprawling stems and slender green leaves. Tiny greenish-white flowers are borne in branching clusters.

GORSE (*Ulex europaeus*)

Gorse is a large, evergreen shrub, covered in needle-like leaves and distinctive, coconut-perfumed brilliant yellow flowers. These bright spiked bushes are closely associated with what we regard as 'wild' landscapes, ranging from coastlines to cities.

GROUNDSEL (*Senecio vulgaris*)

Branched stems support open clusters of yellow flowers that can be seen for much of the year; these turn fluffy and white as the plant seeds. Veins are visible on the outside of the hollow stems and the leaves are long with a few blunt teeth. Individual flowerheads are roughly cylindrical in shape.

HAIRY BITTERCRESS (*Cardamine hirsuta*)

This compact edible herb can be identified by its rosette cluster of small, bright green leaves that radiate out from around the base. The leaves are pinnate and hairy on top, while the stems are straight and hairless. The tiny white flowers have four stamens.

HERB ROBERT (*Geranium robertianum*)

Herb robert has small, pretty, five-petalled pink flowers and reddish stems. The leaves are dark green and deeply dissected and turn red at the end of the flowering season; when crushed they give off an unpleasant odour. It can grow up to 40cm (16in) tall.

KNAPWEED (*Centaurea nigra*)

The thistle-like knapweed has a slightly scaly, spherical, black-brown flowerhead, topped with a 'flower' (actually a cluster of florets known as a pseudanthium) of purple, pink or white. Its leaves are elongated and lance-shaped. The plant tends to grow alone and stands out in grassland.

LESSER CELANDINE (*Ficaria verna*)

The stem and leaves of lesser celandine are bright green; young leaves are heart-shaped, becoming ivy-like with darker markings. The shiny, star-like flowers have 7–12 golden-yellow petals with a green underside. The fruit appears like grains of corn, being globular and whitish.

NETTLE (*Urtica dioica*)

The nettle grows in dense clumps, forming large colonies. Occasionally branching, thin stems support many veined dark green leaves with toothed edges. The leaves are opposite along the stem and both leaves and stem are covered with numerous stinging hairs.

POPPY (*Papaver* spp.)

Poppy flowers have 4–6 petals, with numerous stamens creating a distinctive whorl in the centre of each bloom. The flowers are bright and of almost any colour, with showy large petals, some with markings. After flowering, a spherical seedpod develops topped by a disk.

PURSLANE (*Portulaca oleracea*)

Purslane produces mostly prostrate green or reddish stems, reaching a height of up to 40cm (16in) with thick, almost succulent, paddle-shaped green leaves. It produces yellow, star-shaped flowers from spring to autumn, developing into seedpods that can distribute the seeds over a wide area.

RED CAMPION (*Silene dioica*)

A pretty, bright woodland wildflower, vivid pink in colour with tall, rich green downy stems and leaves. The distinctive five-petalled flowers are fused at the base by a purple-brown calyx that forms a tube. The leaves are oval with pointed tips and are joined to the base of the plant with short stalks.

RED DEAD-NETTLE (*Lamium purpureum*)

This downy, aromatic plant flowers early and has 'hooded' pink-purple blooms carried in dense, two-lipped whorls emerging from heart-shaped, softly toothed leaves, which are quite often tinged with a bronzy-purple hue. The plant never reaches much above 30cm (12in) tall.

RED VALERIAN (*Centranthus ruber*)

Unmistakable dense clusters of deep pink, almost crimson flowerheads on top of tall woody stalks. The display is large and showy, and the plants often colonize areas in large groups. Each bloom smells rather unpleasant. The leaves grow in opposite pairs and are oval in shape.

ROSEBAY WILLOWHERB (*Chamaenerion angustifolium*)

A striking wild plant with lance-like leaves arranged in a spiral ascending the stem. The plant starts as a rosette of leaves before becoming a tall stalk. Large, deep pink flowers, each with flour petals, then form at the top of the reddish stalk, creating vivid spires.

SALSIFY (*Tragopogon porrifolius*)

A tall and stately vegetable plant with a grass-like basal rosette and stem leaves. Knee-high solitary stalks bear composite flowers with spiky green sepals. The single starry flowers are purple ray florets that look much like a daisy, while the fruit looks like a dandelion clock or puffball.

SCARLET PIMPERNEL (*Anagallis arvensis*)

A low-growing plant with tiny bright red flowers that can vary from orange through to salmon, borne singly on long, square stalks with oval leaves. The distinct colour of the flowers makes it easy to spot in a tangle of undergrowth and grasses. The stamens are yellow and upright, like little lollipops.

SELFHEAL (*Prunella vulgaris*)

Selfheal is a low-growing, creeping plant and meadow flower that resembles a wild orchid. Its tiny, two-lipped, lilac or white tubular flowers are densely clustered into prominent short spikes. It bears serrated lance-shaped leaves with reddish tips that grow in opposite pairs.

SPEAR THISTLE (*Cirsium vulgare*)

The spear thistle, like all thistles, is characterized by leaves with sharp spines on the margins. They are grey-green in colour and borne on a tall stem. The flowerheads are bright pink, fluffy florets crowning a ball of spiny, leaf-like structures.

STAG'S HORN SUMAC (*Rhus typhina*)

A small deciduous tree or shrub with spectacular fiery red clusters of berries in autumn, which makes it very popular in gardens. Prior to fruiting, the flower spikes comprise clusters of small, greenish, creamy white or red flowers. The leaves are long and pointed, with brilliant colouring in autumn.

SUN SPURGE (*Euphorbia helioscopia*)

This upright, glabrous, acid-green plant comprises complex, flat flowerheads on stalks, supported by a single stem. Like other euphorbias, the little flowers lack petals and sepals; a circle of obovate, leaf-like bracts encloses a single female ovary surrounded by male flowers.

TEASEL (*Dipsacus fullonum*)

A tall, easily identifiable plant with spiny, egg-shaped flowerheads that appear on top of long stems. The stems have thorns along their length, and cone-like flowerheads with tiny purple clusters of flowers. They are more familiar in winter, when the seedheads have turned brown.

WALL BELLFLOWER (*Campanula portenschlagiana*)

Vigorous and fast-spreading, the wall bellflower forms a dense evergreen mat of foliage, adorned with a mass of bell-shaped, soft, violet blooms. It cascades over sunny areas of rock and soil. Each flower is around 2.5cm (1in) long, borne freely on branching stems.

WATERCRESS (*Nasturtium officinale*)

An aquatic flowering plant, watercress has mid-green, smooth, oval leaves with scalloped edges. Many leaflets grow on thin stems that are slightly paler in colour, crisp and hollow. The plants grow rapidly and often form bushy colonies.

WILD CARROT (*Daucus carota*)

A frothy wildflower with a single red bloom in its centre. The off-white flower clusters are densely packed and long-stalked, shaped like an upturned umbrella. The leaves are lacy and divided into narrow leaflets. The entire plant has a hairy appearance.

YARROW (*Achillea millefolium*)

An erect herbaceous plant with flattened clusters of tiny, daisy-like flowerheads, usually white but sometimes pink, clustered in tight groups to resemble open umbrellas. The leaves are feathery, dark green and finely divided. Yarrow flowers are highly aromatic and smell like a mixture of chamomile and pine.

YELLOW RATTLE (*Rhinanthus minor*)

Yellow rattle has yellow, tube-like flowers that protrude from an enlarged green calyx or husk. It has serrated leaves with dark green veins, which grow in opposite pairs all the way up the black spotted stem. In autumn the large dry fruit capsules rattle with seeds in the breeze, hence the name.

GLOSSARY

ALLANTOIN – a major chemical compound and metabolic intermediate in most organisms, including animals, plants and bacteria.

ANNUAL – a plant that completes its life cycle within one year or less, and can be further divided into summer and winter species, depending on when they begin to grow.

ANTHER – the part of a flower's stamen that contains pollen.

ASTRINGENT – in botany, causing the contraction of skin cells.

AXIL – the angle between the stalk of a leaf and the main stem from which it is growing.

BASAL – forming or belonging to a bottom layer or base.

BETA-CAROTENE – a plant pigment that gives red, orange and yellow vegetables their vibrant colour.

BIENNIAL – a plant that takes two years to germinate, bloom and die. Biennials are the least common type of weed and will germinate in any growing season.

BIOACTIVE – having a biological effect.

BRACT – a modified leaf or scale, typically small, with a flower or flower cluster in its axil. Bracts are sometimes larger and more brightly coloured than the true flower.

BROADLEAF – (of a plant) with flat leaves, netlike veins and grows by a taproot or coarse root system. When they first germinate, two leaves emerge from the seed.

BURR – a seed or dry fruit or fruiting head that has hooks or teeth.

CALYX – a husk or pod that forms a protective sheath.

CLEISTOGAMOUS – a type of automatic self-pollination of certain plants that can propagate by using non-opening, self-pollinating flowers.

COMPOUND – (of a leaf) consisting of several leaflets joined to a single stem.

CRENATE – especially of a leaf or shell, having a round-toothed or scalloped edge.

CULTIVAR – a plant variety that has been produced in cultivation by selective breeding.

DECIDUOUS – a tree or shrub shedding its leaves annually.

DIOECIOUS – the male and female flowers grow on separate plants.

DIURETIC – any drug that increases the flow of urine.

DOWNY – covered with fine, soft hair.

DRUPES – a simple fleshy fruit that usually contains a single seed.

FLORET – a small flower that is part of a larger flower.

FROND – the leaf of a fern.

GENERA – plural noun of genus.

GENUS – a rank in the biological classification (or taxonomy), coming above species and below families.

GLABROUS – free from hair or down; smooth.

HELIOTROPISM – the term used to describe the seasonal motion of plant parts (flowers or leaves) in response to the direction of the sun.

HEMI-PARASITIC – a plant that possesses chlorophyll and typically carries out photosynthesis but is partially parasitic on the roots or shoots of a plant host.

HERBACEOUS – vascular plants that have no persistent woody stems above ground, including many perennials and nearly all annuals and biennials.

HERBALISM – the study and use of medicinal herbs for their healing properties.

HERBALIST – someone who uses plants for healing. A herbalist is not a doctor, though some practitioners are referred to as medical herbalists.

HERMAPHRODITE – an organism that possesses both male and female reproductive organs during its life.

LEAFLET – a leaf-like part of a compound leaf. Though it resembles an entire leaf, a leaflet is not borne on a main plant stem or branch.

LOBED – (of leaves) with distinct protrusions, either rounded or pointed.

MONOCARPIC – flowering only once before dying.

OBCORDATE – (of a leaf) in the shape of a heart with the pointed end at the base.

OBOVATE – (of a leaf) an egg-shaped leaf with the narrower end at the base. A simple leaf that is not divided into parts.

PERENNIAL – a plant that lives at least two years and has the potential to reproduce indefinitely. If you don't remove the entire root system, they will grow back again and again.

PETIOLE – a stalk that attaches a leaf blade to a stem.

PINNATE – (of a leaf) feather-like in shape or having leaflets on each side of a common axis.

PISTIL – the female reproductive part of a flower.

POLLINATOR – an animal that moves pollen from the male anther of a flower to the female stigma of a flower. This helps to bring about fertilization of the ovules in the flower by the male gametes from the pollen grains.

PSEUDANTHIUM – a compact inflorescence of many small flowers that looks like a single flower.

PURGATIVE – strongly laxative in effect.

RHIZOME – a modified stem running underground horizontally. They strike new roots out of their nodes, down into the soil.

ROSETTE – a circular arrangement of leaves or of structures resembling leaves. In flowering plants, rosettes usually sit near the soil.

SEPAL – each of the parts of the calyx of a flower, enclosing the petals and typically green and leaflike.

SILICA – a natural compound, found all around us in nature.

STAMEN – the male reproductive part of a flower.

STIGMA – (of a flower) the top of the pistil, which receives pollen.

STYPTIC – (of a substance) capable of causing bleeding to stop when it is applied to a wound.

TREFOIL – from the Latin *trifolium*, a three-leaved plant.

TRIFOLIATE – (of a compound leaf) having three leaflets.

UMBEL – a flower cluster in which stalks of nearly equal length spring from a common centre and form a flat or curved surface.

VASCULAR – relating to, affecting, or consisting of a vein or veins.

WEED – a wild plant growing where it is not wanted and in competition with cultivated plants.

WHORL – a pattern of spirals or concentric circles.